To my boys, Asher Jet and Griffen Jack, with the fervent hope that my passion for this subject will not spoil their curiosity for it

CONTENTS

INTRODUCTION AND ACKNOWLEDGEMENTS

Thirty-two miles from the U.S. Capitol, just west of a small, trickling stream known as Bull Run, blue and gray-clad soldiers fought two of the major battles of the Civil War, First Bull Run and Second Bull Run. Both were massive defeats for the Union Army, and so its battlefields were not immediately accessible to the northern photographers who took nearly all of the wartime documentary photographs.

Despite the importance and popularity of the two battles, and the myths and misconceptions associated with the photographic efforts at Bull Run, this work is the first to specifically address the photography associated with its battlefields. Although Mathew B. Brady equipped two full wagons and followed the Union Army to Bull Run in 1861, neither he nor any other photographer is known to have secured a single image before or soon after that first major land battle of the war. The only photographic team to visit the area during the four years of the war came in March 1862, between the first and second battles, and most of the places where the photographers did expose their glass plates are identifiable today. Some of their images are mislabeled as showing Blackburn's Ford, but in fact it was more than 20 years after the war before any images were taken of this key Bull Run crossing. These and many other associated issues have never before been examined broadly and I hope that this work is just the beginning of enhanced study of the photographs of the Manassas battlefields.

A few close friends in particular have admirably advanced the study of Bull Run photography. Manassas National Battlefield Museum Specialist Jim Burgess, the battlefield's living encyclopedia, has studied area images for decades and made some of the key discoveries presented in this book. Jim's research, organization and assistance were essential to this work. He conducted a review of the book, offered numerous comments and made more than a few key saves before it went to publication. Keith Knoke, who has become intimately familiar with the battlefields and their imagery, made key discoveries associated with the 1862 Henry Hill series and helped make this work far more revealing than it otherwise would have. It is not surprising that my mentor, William A. Frassanito, whose work is to my career as South Carolina's secession is to the Civil War, has also advanced the field in this area. His research on Mathew Brady in 1861 as well as the series containing the "Confederate Dead on Matthews Hill" photo, debunked multiple myths at once when first published more than 30 years ago. Bob Zeller, who has written by far the best overall book on the history of Civil War photography and the men behind the cameras, *The Blue and Gray in Black and White*, not only significantly added to the scholarship of 1861-62 photography, but also edited every word of text herein. Bob has, for a long time, made me appear to be a better writer than I actually am.

I am likewise lucky to have been provided access to the best collections of Manassas-related photographs. In addition to what I call the triumvirate of key Civil War photography repositories—the Library of Congress (LC), the National Archives and Records Administration (NARA) and the Army Heritage Education Center (AHEC), I also had full access to the Manassas National Battlefield's (MNB) unparalleled collection of wartime and postwar views of the Bull Run battlefields. Their postwar views, some recorded several decades or more after the conflict had ended, essentially allowed my 'then & now' approach to become a 'then & then & then & now' presentation. Although I did not use any images from the incredible collections of Ohio's Western Reserve Historical Society, that institution should be mentioned as well. Dayton History, which houses the largely untapped Albert Kern Collection, proved once again to be a treasure trove. Albert Kern visited the Manassas battlefields at least six times in the 1890s and 1900s and most of his thousands of glass plate negatives of numerous Civil War sites have never even been printed, let alone published. The National Portrait Gallery also provided one absolutely critical image herein from its Larry J. West Collection.

My good friends Bob Zeller, Robin Stanford and John Richter allowed me access to more images than I could possibly use in this book. All have unpublished gems in their collections and I am a better historian because of them. Bob, John and I serve on the board of directors of the Center for Civil War Photography (CCWP), the nonprofit organization that published this work. Since its founding in 1999, the Center has always spoken my language—that of preserving, studying, using, promoting and making available all manner of Civil War-related imagery. I am exceedingly fortunate to be part of such a dedicated and curious group of people as the CCWP's members and directors. The Center's executive director, Jennifer Kon, is a tireless, efficient and mature leader who designed this book and put up with numerous ongoing and last-minute changes to every aspect of it. She is the unsung hero of the Center, making the organization run for nearly a decade with little notice or acclaim. I also received critical feedback and generous assistance from fellow CCWP board member Ron Perisho. My friend and CCWP researcher John Kelley listened to my burgeoning Manassas theories and provided a key historic image for the book.

I hope that this book will spur additional study, solve Manassas-related photomysteries and, most importantly, provide that indescribable joy I feel when connecting with the past through photography. If this book fosters even a glimmer of that feeling in one reader, I shall be perfectly satisfied.

Garry E. Adelman
Brunswick, Maryland
June 2011

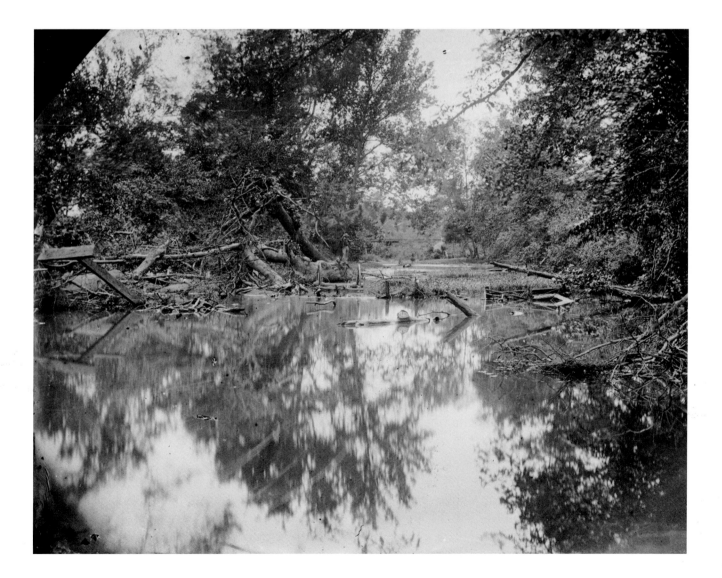

THE BATTLES OF MANASSAS

In the wake of the Civil War's opening salvos at Fort Sumter, South Carolina, in April 1861, the Union and the Confederacy raised tens of thousands of troops. Both sides amassed armies around the United States capital. As troops on both sides trained and drilled on the rolling hills in and around Washington and northern Virginia, the Yankee press clamored for action. They demanded that the mighty Union forces – growing by the hundreds each day in the spring and summer of 1861 – push the traitorous Rebels away from Washington and all the way back to their own capital with the rallying cry, "On to Richmond!" General Irvin McDowell, newly assigned commander of the Union troops around Washington, was under intense pressure to move before the 90-day enlistments of the Union troops expired. Confederate soldiers around Washington, under the command of General Pierre G.T. Beauregard, had no such provision and thus felt no similar urgency as they laid out a defensive line along a meandering stream west of Washington called Bull Run. The Bull Run position protected the vital rail junction at Manassas and guarded the key roads to Richmond, 90 miles south of Washington.

Both sides also had smaller armies in the Shenandoah Valley some 50 miles northwest of Manassas. Soon after McDowell's army marched westward to confront Beauregard on July 16, the Confederate forces in the Valley, under General Joseph E. Johnston, slipped away from the Union Army under General Robert Patterson, marched to the Manassas Gap Railroad, boarded cars and began riding to Manassas. As the armies gathered around Manassas and Centreville, their numbers swelled to roughly 30,000 on each side. Both sides expected the fighting to erupt near Beauregard's center or right flank, and so it did. On July 18th, Confederate troops got the better of a Union brigade at Blackburn's Ford. One hundred fifty men were killed, wounded or captured. McDowell needed a new plan, and he came up with a good one.

Three days later, on July 21, while screening his movement with one division, McDowell moved some 13,000 troops to the north on a wide sweep around the Confederate left flank, where a stone bridge crossed Bull Run. The Union plan worked, despite confusion and delay, and McDowell found himself squarely on the flank and in the rear of his enemy by midmorning.

But Confederates got word of the flank march. A small force went to stop the Yankees. They met on Matthews Hill and the fighting quickly grew in size and ferocity. After 90 minutes, the outgunned Confederates fell back. The road to Richmond was now largely open to McDowell, if only he would take it. But this was the war's first battle; both sides were badly disorganized. McDowell gave the Confederates the greatest strategic gift of all—time. For two hours, McDowell ordered no forward movement. By then the Confederates had grown much stronger and were positioned on an eminence now known as Henry Hill.

When the Union finally moved forward, most of Joseph E. Johnston's Valley troops had arrived in the vicinity. Throughout the afternoon, Johnston funneled Confederate troops to Henry Hill while Beauregard directed the battle. It proved a recipe for success. As the Union moved artillery and infantry up Henry Hill, piecemeal, Beauregard's force countered. Again and again, Union troops crested Henry Hill and gained some success but were ultimately pushed back. As the day wore on, the Confederates became stronger and the Union troops weakened. When the last fresh Union brigade arrived on an eminence now known as Chinn Ridge, it was already completely outflanked and outnumbered. The battle was all but over.

Union troops fell back from whence they came, first with some semblance of order but later in panic, listlessly pursued by a disorganized Southern army that was just as inexperienced as the Federals. Union troops made it back to Washington after suffering staggering losses in men and materiel. Almost 3,000 Union casualties and some 1,750 casualties made this day the bloodiest in American history up to that time. Although the Confederates won the battle, it was at once a great wake-up call to both sides this Civil War would be longer, bloodier and more costly than anyone thought.

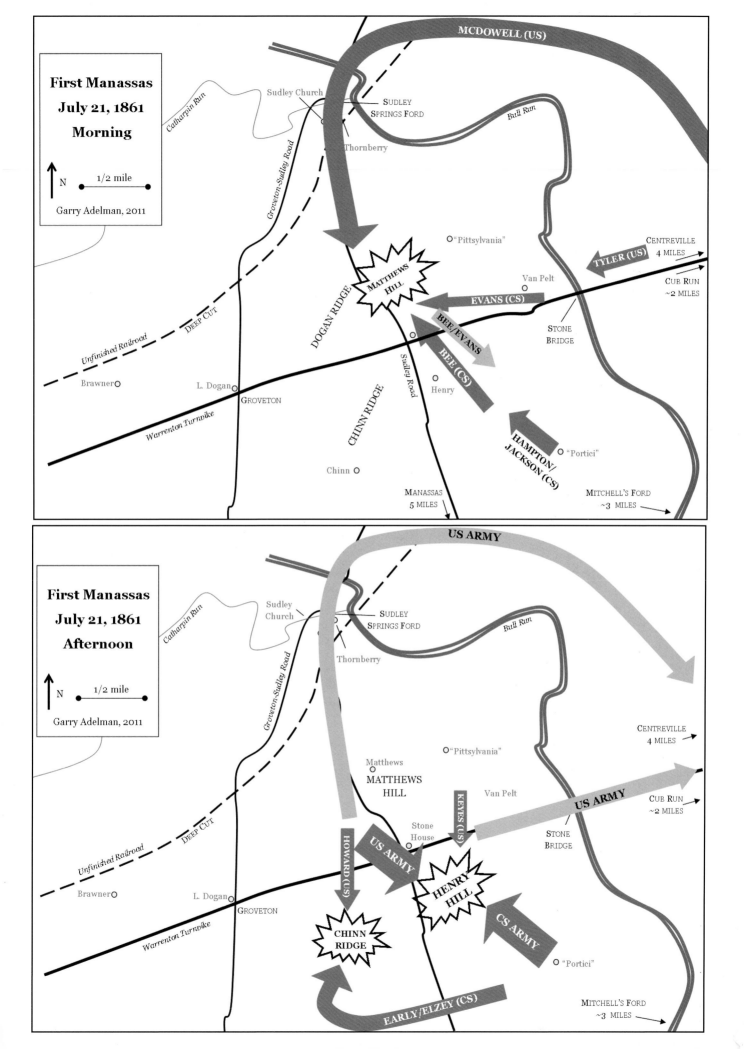

First Manassas
July 21, 1861
Morning

N 1/2 mile

Garry Adelman, 2011

MCDOWELL (US)

Catharpin Run

Sudley Church

SUDLEY
SPRINGS FORD

Bull Run

Thornberry

Groveton-Sudley Road

"Pittsylvania"

CENTREVILLE
4 MILES

MATTHEWS
HILL

TYLER (US)

Van Pelt

CUB RUN
~2 MILES

DOGAN RIDGE

EVANS (CS)

DEEP CUT

BEE/EVANS

STONE
BRIDGE

Unfinished Railroad

BEE (CS)

Brawner

L. Dogan

Henry

GROVETON

CHINN RIDGE

Sudley Road

HAMPTON/
JACKSON (CS)

"Portici"

Warrenton Turnpike

Chinn

MANASSAS
5 MILES

MITCHELL'S FORD
~3 MILES

First Manassas
July 21, 1861
Afternoon

N 1/2 mile

Garry Adelman, 2011

US ARMY

Catharpin Run

Sudley
Church

SUDLEY
SPRINGS FORD

Bull Run

Thornberry

Groveton-Sudley Road

"Pittsylvania"

Matthews

MATTHEWS
HILL

CENTREVILLE
4 MILES

Van Pelt

KEYES (US)

US ARMY

CUB RUN
~2 MILES

DEEP CUT

Stone
House

STONE
BRIDGE

Unfinished Railroad

HOWARD (US)

US ARMY

Brawner

L. Dogan

HENRY HILL

GROVETON

CS ARMY

CHINN
RIDGE

Warrenton Turnpike

"Portici"

EARLY/ELZEY (CS)

MITCHELL'S FORD
~3 MILES

The Confederates encamped around Manassas and nearby Centreville the rest of the summer, fall and most of the winter. On March 9, 1862, the Southern troops evacuated Manassas and moved toward Richmond to defend their capital from Union General George McClellan's giant Army of the Potomac. After advancing westward toward Richmond, McClellan and his Peninsula Campaign came to an end after the bloody Seven Days Battles, when new Confederate General Robert E. Lee backed McClellan's army against the James River, and the Union forces were forced to withdraw. As this campaign ended, disparate Union forces from the Shenandoah Valley were assembled along the Rappahannock River under the command of General John Pope. Lee desired to strike at that force of roughly 60,000 soldiers before McClellan could move his full force northward and combine his strength with Pope.

Lee moved Stonewall Jackson's troops first, then Longstreet's. Jackson's troops clashed with part of Pope's force at Cedar Mountain on August 8th. Jackson and his men, as well as cavalry under General Jeb Stuart, made a wide flanking movement and successfully gained Pope's flank and rear, sacking Manassas Junction along the way. Pope moved to trap Jackson near Manassas before Longstreet could arrive but Jackson moved too quickly, taking position just west of the Bull Run battlefield on a ridge along an unfinished railroad bed. From there, Jackson could guard the route of Longstreet's approach and have a means to escape if he needed to.

On August 28th Jackson's 25,000 soldiers picked a fight with some of Pope's men as they passed by. A savage, stand-up fight ensued at Brawner's Farm. For the next day and a half, Pope's soldiers launched piecemeal attacks which pierced the strong Confederate line. Jackson was pushed to his limit but each time, his veteran soldiers managed to push back the unsupported Union forces. By August 30th, Longstreet's troops had arrived and, after the largest Union attack near the Deep Cut had failed, Longstreet launched one of the most powerful offensives of the Civil War. Twenty-five thousand Confederates moved forward, generally south of and parallel to the Warrenton Turnpike, outnumbering Union troops south of the Pike by more than ten to one. It was another Union rout, but in staving off the complete destruction of the Union army, John Pope and the tenacious stand his soldiers took deserve credit. Darkness brought an end to the battle, with the Union army again fleeing toward Washington.

The Second Battle of Manassas was one of the bloodiest battles of the Civil War. Although Lee inflicted 13,800 casualties to Pope's forces while suffering some 8,300 himself, he had failed to achieve his objective— his sole objective almost every time he fought— in destroying his opponent. Maintaining a near status quo, Lee entered Maryland the following month with a tired and weakened army.

WHAT'S IN A NAME?

In a war in which numerous engagements are known by multiple names, it was the first great land battle that set the stage for confusing nomenclature. The war's opening land battle became known as the Battle of Manassas by the Southerners, while the North knew it as the Battle of Bull Run. After the second battle there, the first conflict became known by a number of names, including First Manassas, First Battle of Manassas, Battle of First Manassas, Battle of Bull Run, Bull Run, First Battle of Bull Run and Battle of First Bull Run. All of these and more are in common, and often conflicting, use today.

Generally, the Confederacy tended to name armies and battles after geographic areas or towns while the Union preferred rivers. Therefore, the Confederate Army of Tennessee and the Union Army of the Tennessee are on opposite sides. To the South, the war's bloodiest day was the Battle of Sharpsburg, to the North it was the Battle of Antietam. But there was no set rule and that was particularly true at Manassas. One of the Confederate armies was called the Army of the Potomac—a moniker later famous used by a Union army. Since the Confederates won both battles at Manassas, and since both were fought in Virginia, the site is officially known by the National Park Service as Manassas National Battlefield; with the engagements themselves called the Battle of First Manassas and the Battle of Second Manassas. Despite this, Bull Run is a far more familiar moniker for the battlefields. I have opted herein to fully embrace the confusion of the multiple names and use Bull Run and Manassas interchangeably.

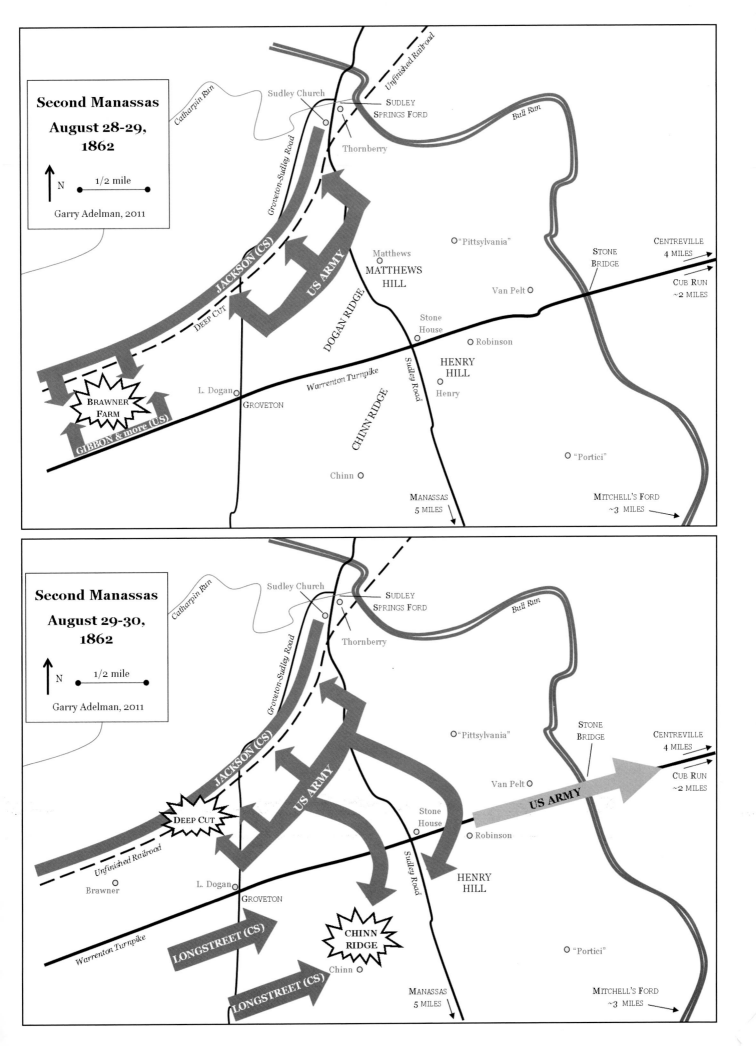

Second Manassas

August 28-29, 1862

N 1/2 mile

Garry Adelman, 2011

Catharpin Run

Sudley Church

SUDLEY SPRINGS FORD

Unfinished Railroad

Bull Run

Thornberry

Groveton-Sudley Road

JACKSON (CS)

US ARMY

DEEP CUT

"Pittsylvania"

CENTREVILLE 4 MILES

STONE BRIDGE

Matthews

MATTHEWS HILL

Van Pelt

CUB RUN ~2 MILES

DOGAN RIDGE

Stone House

Robinson

HENRY HILL

BRAWNER FARM

L. Dogan

GROVETON

Warrenton Turnpike

Sudley Road

Henry

GIBBON & more (US)

CHINN RIDGE

Chinn

MANASSAS 5 MILES

MITCHELL'S FORD ~3 MILES

Second Manassas

August 29-30, 1862

N 1/2 mile

Garry Adelman, 2011

Catharpin Run

Sudley Church

SUDLEY SPRINGS FORD

Bull Run

Thornberry

Groveton-Sudley Road

JACKSON (CS)

US ARMY

DEEP CUT

"Pittsylvania"

STONE BRIDGE

CENTREVILLE 4 MILES

Unfinished Railroad

Van Pelt

CUB RUN ~2 MILES

US ARMY

Brawner

L. Dogan

Stone House

Robinson

GROVETON

Warrenton Turnpike

Sudley Road

HENRY HILL

LONGSTREET (CS)

CHINN RIDGE

Chinn

LONGSTREET (CS)

MANASSAS 5 MILES

"Portici"

MITCHELL'S FORD ~3 MILES

PHOTOGRAPHERS AND PHOTOGRAPHS

The art of photography was already more than two decades old when the Civil War started. By 1861, technological advancements and a growing marketplace provided the perfect environment for a photographic boom. The growth of the collodion wet plate process, which produced a glass-plate negative that was easily reproducible on light-sensitive paper, triggered the widespread marketing and sale of photographs to the public in the forms of cartes-de-visite—small card photographs – and stereoviews, dual image cards which, when placed in a special viewer, produced a 3D effect. With the technology available to capture scenes from the field – if not battle itself – and a public clamoring for information and imagery like never before, the Civil War was tailor-made for an explosion of photojournalism.

Southern photographers shot first, securing 2D and 3D photographs of Fort Sumter within days of its surrender in April 1861. This was no small feat. Of the thousands of American photographers in 1861, few had the knowledge, skill or equipment necessary to take pictures away from the comfort of their studios, and even fewer had a way of marketing images beyond their own studios. In Washington, Brady readied his mobile darkroom wagons for action, but had to wait for something to happen. In the months following Fort Sumter, the camps of the troops gathered in and around Washington, DC, provided the best documentary possibilities for Brady and other Northern cameramen.

Mathew B. Brady was the most famous photographer in America in 1861, operating lavishly appointed galleries in New York and Washington. Brady was intent on making a photographic record of the war and personally went into the field during each year of the conflict. Most of the best-known Civil War photographers worked at some point for Brady. The organized and innovative Scotsman Alexander Gardner managed Brady's Washington gallery until opening his own in 1863. Other talented Brady "photographists," as they were sometimes called back then, included George Barnard and James Gibson, who took most of the wartime images of the First Bull Run battlefield, and Timothy O'Sullivan. Capt. Andrew J. Russell was the only Union army officer to work as a full-time photographer, learning the craft in early 1863 from a Brady employee. Together, these six photographic artists and their assistants created nearly every Civil War-era photograph taken around Manassas.

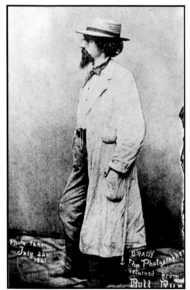

Mathew Brady, upon return from his Bull Run expedition, July 22, 1861, LC. This is the only 1861 Brady photograph related in any real way to the Battle of Manassas.

Brady's personal presence at Bull Run was documented by New York *Tribune* correspondent William A. Croffut, who said the famous photographer "wore a long linen duster, and strapped to his shoulders was a (camera) box as large as a beehive." George Barnard also went, stopping to help a wounded Union soldier on the frantic retreat. Despite statements to the contrary over the past 150 years, and an intriguing contemporary account in a photographic periodical describing incomparable photographs taken "amidst the excitement, the rapid movements and the smoke of the battlefield," no photographer is known to have secured a single image of the Bull Run battlefield in 1861. Northern photographers were caught up in the Union retreat from the battlefield and had no access to it as long as Confederates remained in the area. For through examinations of Brady's journey to Bull Run, as well as a deeper discussion of the first year of Civil War photography, see William A. Frassanito, *Antietam: The Photographic Legacy of America's Bloodiest Day*, and Bob Zeller, *The Blue and Gray in Black and White: A History of Civil War Photography*.

In the waning months of 1861, as the Confederates camped around Manassas and Centreville, Virginia, photographers kept busy in other areas. Oddly, the first real photographs associated with the Battle of Bull Run were recorded in

South Carolina. Charleston photographer George S. Cook captured the war's first images of prisoners of war when he went to Castle Pinckney in Charleston Harbor and photographed Union soldiers being held there who had been captured at Bull Run. The next significant coverage of a war zone, in the first months of 1862, also occurred in the Palmetto State when Northern photographer Timothy O'Sullivan exposed a series of plates around recently-captured Port Royal Sound and, outside Savannah, Georgia, the recently occupied Fort Pulaski.

Manassas and Centreville were evacuated by Confederate forces on March 9, 1862, allowing Union soldiers and Northern photographers access to the first great battlefield of the war more than seven months after the fighting ended. The first to arrive were George Barnard and James Gibson, working for Brady, along with at least two assistants. They brought with them a large format "plate" camera and a smaller "stereo" camera with which to take 3D images. Visiting Centreville, Manassas, and the fields of battle, this team exposed more than 70 photographs of these now-famous places. Despite the battlefield's proximity to Washington, Barnard and Gibson were the only photographers to cover the battlefield proper during the Civil War.

Later that spring, Barnard and Gibson traveled to the Virginia Peninsula along with George McClellan's Union army and advanced as slowly as McClellan did, taking numerous pictures along the way. Among them was what writer and photohistorian Bob Zeller considers the first, great documentary photograph of the war— a stereo view by Gibson of wounded Union soldiers shown in all manner of suffering at a makeshift field hospital at Savage Station. Timothy O'Sullivan kept busy as well. Having returned from Georgia and South Carolina, O'Sullivan secured at least fifteen images around Manassas in July 1862, but did not expose any plates on the Bull Run battlefield. In August, he moved on to Culpeper, Warrenton, and Cedar Mountain, where he inched ever closer to more graphically showing the horrors of war with his photograph of dead horses on the Cedar Mountain battlefield. Later that month, Union and Confederate forces found themselves fighting at Bull Run again but this clash, which largely took place just west of the First Bull Run battlefield, saw fighting on a scale that made the first battle look like a warm-up exercise.

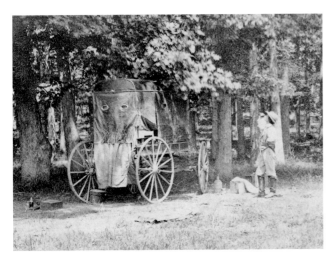

Timothy O'Sullivan's darkroom wagon near Manassas, July 1862, LC. O'Sullivan's assistant stands near the wagon in what has often been called an 1861 photo on the battlefield of Bull Run.

In September 1862, after the battle of Antietam, Alexander Gardner, under Mathew Brady's employ, became the first to score the war's great photographic coup—dead soldiers as they fell on the battlefield. In the following months, as the number of battlefields multiplied, the number of war photographers grew as well, and the number of documentary photographs swelled into the thousands. But the feat that Gardner first accomplished at Antietam —photographing dead American soldiers in the field—was repeated only six more times during the war.

While soldiers remained on active duty around Manassas throughout the war, battles and cameramen were not seen there in the last two years of the conflict. Captain Andrew J. Russell, the official photographer for the Union military railroads, recorded a series of railroad-related photos at Union Mills, near Manassas, and also captured a beautiful picture of William Weir's Manassas home—Liberia.

As host to the first great battle of the war, Bull Run was among the first to be memorialized in its wake. On June 11, 1865, Alexander Gardner (who had split from Mathew Brady in 1863 to start his own gallery) led a team to cover the dedication of two large monuments erected at the Manassas battlefields. His series, limited in breadth and topic, marked only the second time the Manassas battlefields were photographed. For the next two decades, photographs were either rarely taken or have not survived. In the 1890s and 1900s, Dayton,

Ohio, amateur photographer Albert Kern secured at least 80 photographs of the First and Second Manassas battlefields. Extant photographs from the following decades are far more common, especially after the Manassas National Battlefield was created in 1940. Some areas of the battlefield are not known to have been photographed until the mid-20th century.

The dates of the historic photographs in this book span 126 years—starting with Brady's return from Bull Run, July 22, 1861, to the relocation of the Lee-Longstreet monument in 1987. This range – stretching over more than a century – exemplifies the haphazard and scattered nature of the photographic coverage of the Manassas battlefields. I recorded the modern images between 1999 and 2011. Just as Brady, Barnard and Gardner altered elements of their photographic processes with emerging technologies, so did I. When I started recording these modern photographs with my Nikon FG20 camera, I was exposing a negative to light, just as had my Civil War predecessors. Within a few years, however, my switch to a digital Nikon Coolpix camera, which eliminated the need for a physical negative in the recording process, was a change more radical than anything Civil War photographers experienced, or could have even conceived. I shot some of the last modern photos in the book with a Fujifilm Finepix Real3D digital camera. The images actually appear in 3D on the camera's screen the instant they are recorded -- without the need for glasses. It makes one wonder what will come next.

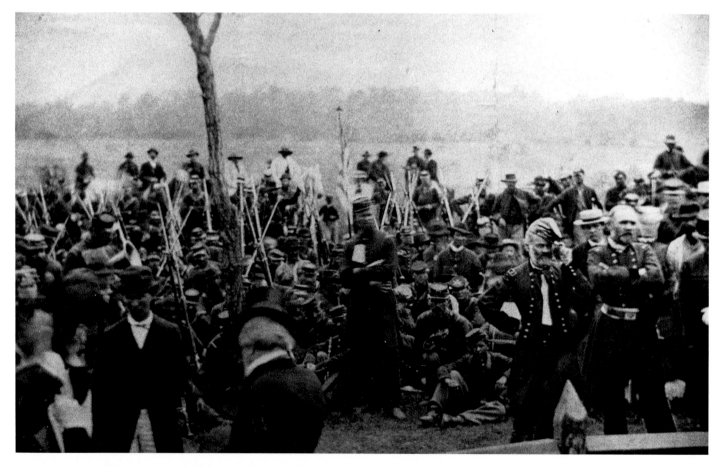

Soldiers and civilians at the dedication of the Bull Run Monument, William Morris Smith for Alexander Gardner, June 11, 1865, MNB. This rare instance of a candid documentary photograph shows Union Generals Heintzelman and Meigs (at right) during a lull in the ceremonies.

THE ARMIES FACE OFF

In July 1861, the Civil War was nearly three months old and a major battle had yet to be fought. Troops from both sides massed around Washington and Northern Virginia, hoping to take part in what most expected to be a short war that would be decided by the coming battle. After the Union Army marched into Virginia to confront the Confederates, the opposing armies were positioned but a few miles apart—the Union, under General Irvin McDowell, around Centreville and the Confederates, under General P.G.T. Beauregard, around Manassas. They fought on Henry Hill and south of Sudley Ford in what became known as the First Battle of Manassas. The tide of battle shifted back and forth until the Rebels beat the Yankees, and Union troops fell back to Centreville and then further toward Washington. The Confederates encamped at Centreville and Manassas through the summer and fall, not giving up this territory until March 1862, when they withdrew from these positions and moved south to better protect their capital at Richmond. Only then, nine months after the fighting, did photographers document the war's first great battlefield. Union photographers George Barnard and James Gibson, carrying a large-format "plate" camera, a smaller stereoscopic (3D) camera and with at least two assistants, accompanied the Union army as it advanced into recently Confederate-held territory and went to work with their cameras.

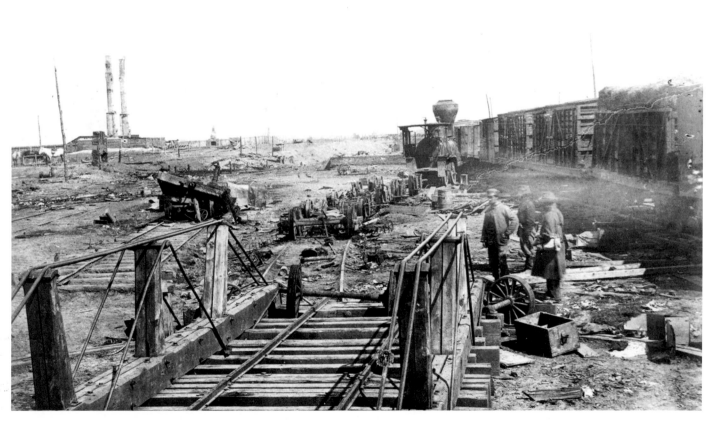

Manassas Junction, Virginia, Barnard & Gibson, 1862, LC. In the summer of 1861, Robert E. Lee, a newly commissioned Confederate general, determined that the strategically important rail junction at Manassas, where the Manassas Gap Railroad joined the Orange and Alexandria Railroad, must be held. During the Battle of First Manassas, Confederate troops under General Joseph E. Johnston arrived at Manassas Junction and provided most of the fighting power that led to Southern victory. When Johnston evacuated Manassas in early March 1862, Confederate troops burned railroad cars and buildings. Just five months after this March 1862 photograph was taken, Confederate troops under Stonewall Jackson seized Manassas Junction during the campaign that led to the Second Battle of Manassas.

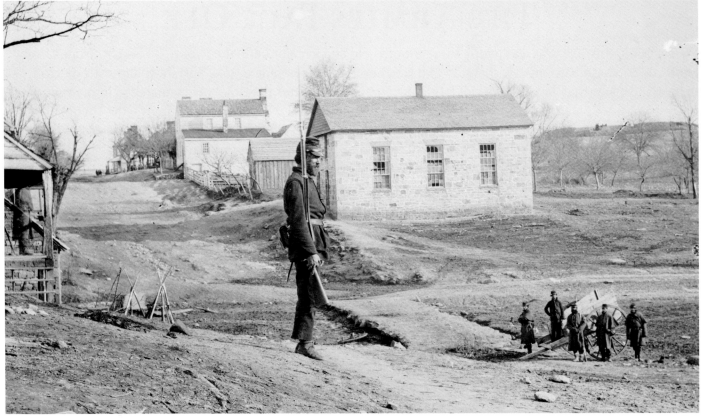

Centreville, Virginia, Barnard, March 1862, LC. The Town of Centreville was established some seven decades before the Civil War, and the conflict left its landscape marred for decades after. "War crushed it, piled earthworks upon its ruins to protect hostile camps, built cantonments in its gardens, and made hospitals of the churches," wrote photographer Alexander Gardner. But through the ages, the Stone Church, near which Union soldiers stand, with unoccupied Confederate fortifications in the background, has endured. It sits in the center of the modern photo, though partially obscured. The church served as a hospital after the fighting at Blackburn's Ford in 1861 and after both Battles of Manassas.

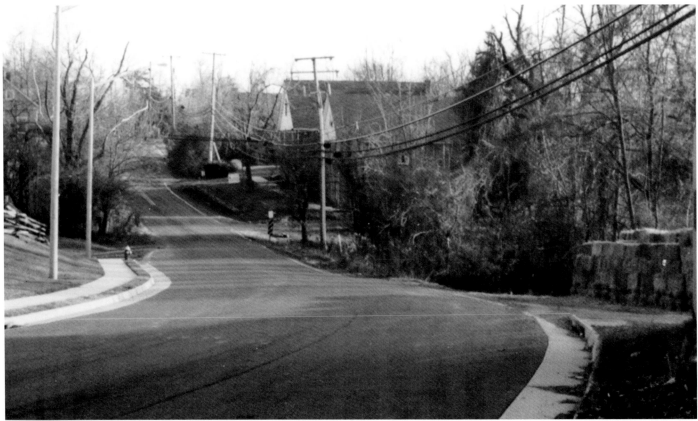

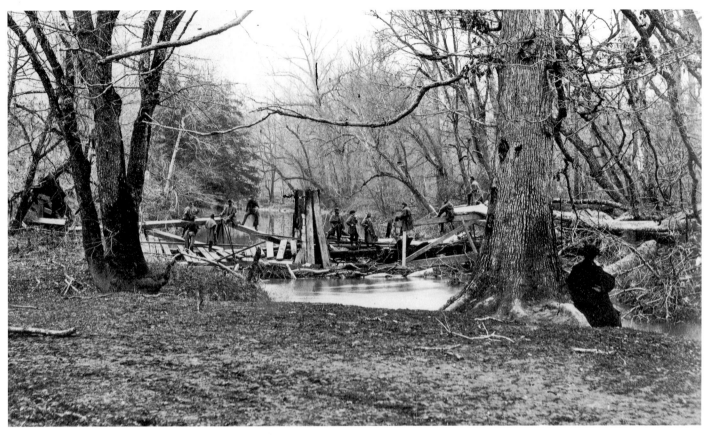

Destroyed Confederate Railroad Bridge, Barnard, March 1862, LC. Before the First Battle of Manassas, Confederates closely guarded the Bull Run bridges and fords. Fighting erupted at Blackburn's Ford. More than 15 Civil War images were identified as having been taken on Bull Run at Blackburn's Ford. None were. In actuality, these images either show Welford's Ford, near Brandy Station, or, as pictured here, the site of a Confederate railroad crossing about a mile up Bull Run from Blackburn's Ford. Confederates built this railroad bridge in December 1861 and then destroyed it when they evacuated Manassas in March 1862. Other than some erosion on Bull Run's banks, the site looks much as it did in 1862.

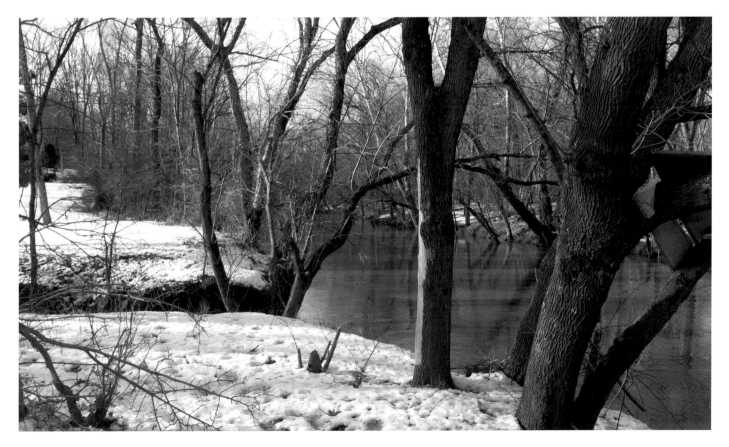

CONFIRMING A PHOTO SITE

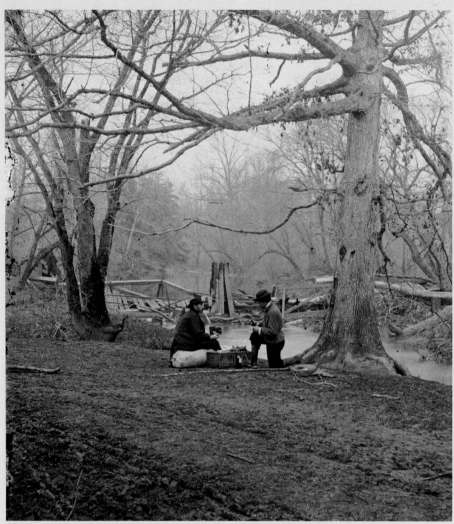

The two photographers' assistants, picnicking along Bull Run, appear in numerous images in the Barnard & Gibson March 1862 series, LC.

Within the depths of the thousands of photographs of the Civil War are hundreds of enduring Civil War photo mysteries. Although many may never be solved, every year Civil War photo historians make discoveries and find answers to these mysteries and, bit by bit, advance the field of study pioneered by the dean of modern Civil War photographic scholarship, William A. Frassanito. Often, pictures of, say, famous officers in wooded camps just don't provide enough clues to locate the sites where they were recorded. Some images, however, especially those recorded in series, allow for real photographic detective work that can bring numerous disciplines to the fore.

In March 1862 George Barnard and James Gibson recorded five images – four large plates and one stereoscopic -- showing a destroyed bridge over Bull Run. Images in this series are usually identified as Blackburn's Ford, Mitchell's Ford or even the Stone Bridge. Manassas National Battlefield Museum Specialist Jim Burgess was confident that the images were recorded at a railroad bridge known to have been built and then destroyed by Confederates at a location far from Blackburn's Ford, somewhere between Mitchell's Ford and where Cub Run flows into Bull Run. Some period captions even identify it as such. Period maps show the railroad line crossing Bull Run just west of Mitchell's Ford and the images show that the land on the camera side of Bull Run rises steeply in the background. Viewing in 3D, it becomes clear that what appears to be a small depression just past the picnicking photographers is in fact a rivulet emptying into Bull Run. Three of the images were recorded below the rivulet and two above. As with almost all Civil War photo mysteries involving the location of an image, a field investigation was needed. This is one of the rare instances when it all worked out.

On February 3, 2011, I walked the length of the targeted area of Bull Run on the northwest side of the stream, looking in particular for the rise of ground above the wrecked bridge, the apparent zigzag curve of Bull Run, the rivulet and any trace of the old railroad bed. I found the latter almost exactly where the map indicated and there was only one rise of ground on the opposite side of the stream that matched that in the images. Upon crossing to the other side and reaching the place where I could gaze up to the rise of ground everything fell into place. All the requisite features were exactly where they were supposed to be. I knew I was standing right where Barnard and Gibson had placed their cameras (and apparently had a picnic) nearly 150 years ago.

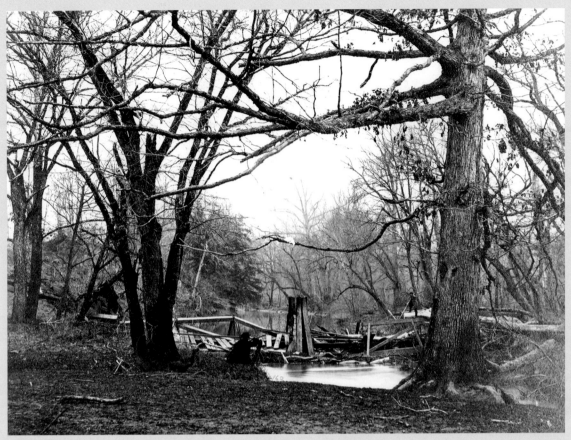

Here, the photographers have switched to their larger plate camera and the assistants are positioned on the far side of the rivulet and on the bridge wreckage, MNB.

This is one of the two images recorded above the rivulet and clearly shows substantial Confederate earthworks at left. In the other version of this image, not printed here, a group of Union soldiers is standing behind and are dwarfed by the earthworks, MNB.

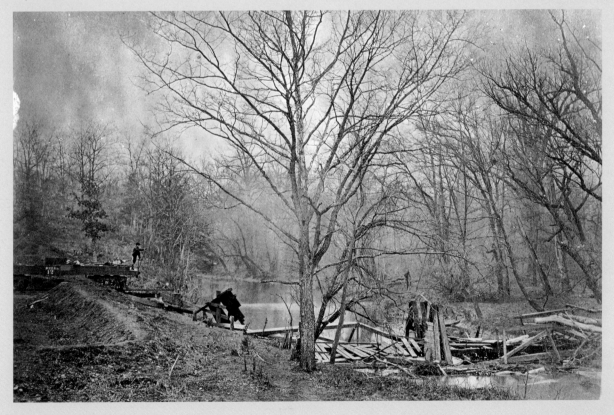

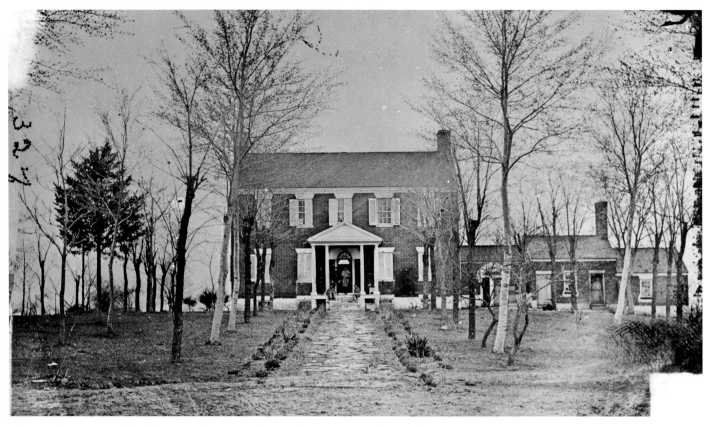

Liberia, the Home of William Weir, Barnard, March 1862. LC. When William Weir built Liberia around 1825, he could have not foreseen the historic events that would transpire there more than 35 years later. Upon arrival in Manassas on June 1, 1861, Confederate General Beauregard established his headquarters at Liberia and spent months there. Presidents Jefferson Davis and Abraham Lincoln stopped at the home in 1861 and 1862, respectively. Union Generals McDowell and Dan Sickles made Liberia their headquarters at points during the war. Although the land holdings surrounding Liberia are decidedly smaller than in the 1860s, the house remains in an excellent state of preservation under the care of the City of Manassas and is part of the Manassas Museum System.

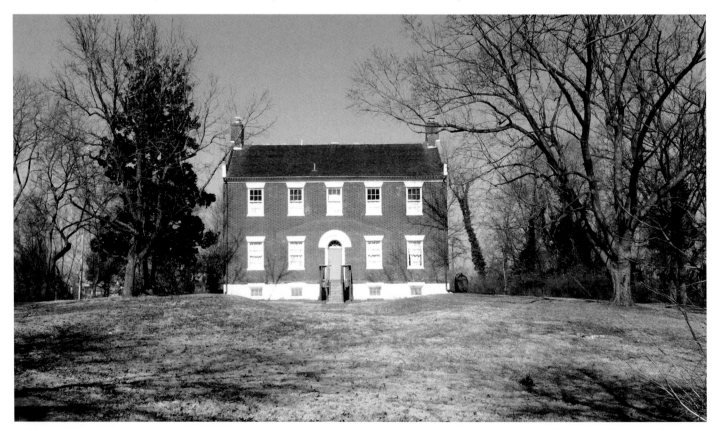

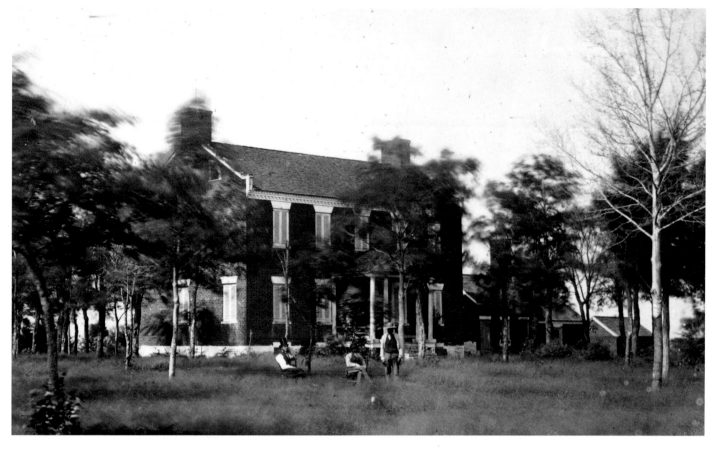

"General Beauregard's Headquarters at First Battle of Bull Run," Andrew Russell, 1863, LC. William Weir's house has, ever since the Civil War, been identified in captions as that of Wilmer McLean, whose house, Yorkshire, was nearby. There are no known photographs of Yorkshire, however. Weir's home is among very few Manassas-area features that was photographed by three different Civil War photographers—in this case Barnard, O'Sullivan and Russell.

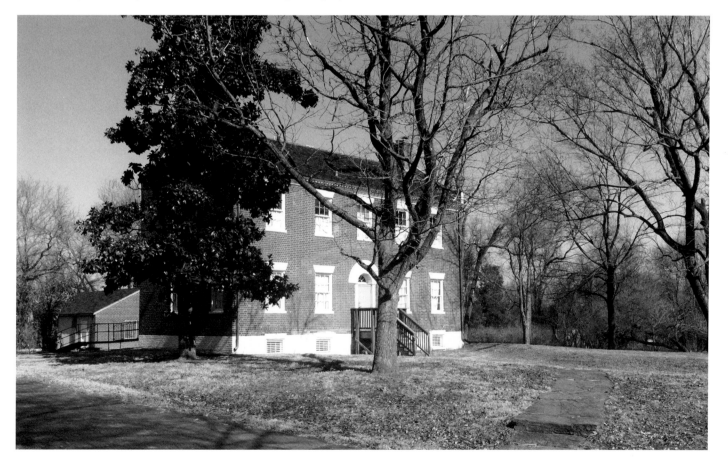

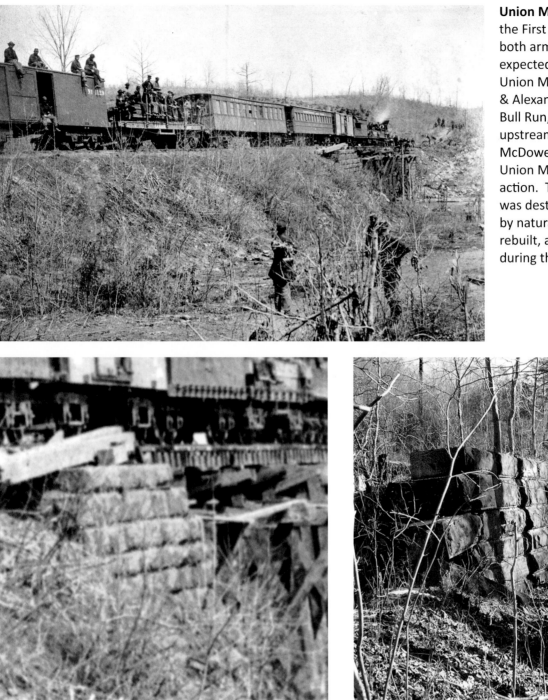

Union Mills, 1862, NARA. Before the First Battle of Manassas, both army commanders expected the fighting to be near Union Mills, where the Orange & Alexandria Railroad crossed Bull Run, rather than further upstream. But Union General McDowell changed his plans and Union Mills saw no significant action. The railroad bridge was destroyed by soldiers, or by natural disaster, and then rebuilt, at least seven times during the war.

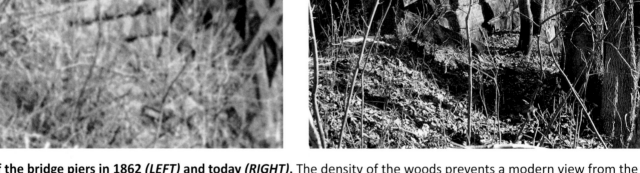

Detail of the bridge piers in 1862 *(LEFT)* and today *(RIGHT)*. The density of the woods prevents a modern view from the same location.

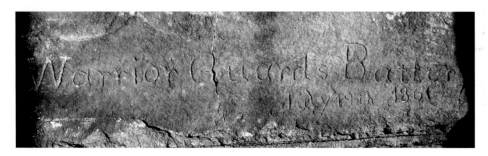

Confederate Carving on Bridge Pier. Both Union and Confederate carvings can be found in the pier stones on the Prince William side of Bull Run today. The inscription pictured here was apparently carved just two days before the Civil War's first, great battle and refers to Company "H", Warrior Guards, 5th Regiment Alabama Volunteers, which was positioned at the bridge at that time.

THE WARRENTON TURNPIKE

The Warrenton Turnpike, modern Route 29, is strongly connected with both Battles of Manassas. In 1861, General McDowell used the rocky, uneven turnpike as his main route of advance from Centreville. The Confederate left flank sat squarely across the turnpike where a stone bridge, known simply by that name, spanned Bull Run. Confederates pursued the retreating Union army on the same road later that day. At Second Manassas, Confederate General "Stonewall" Jackson, returning to the area where he had received his sobriquet the year before, selected his position near the Groveton in part to maintain watch and control over the key road through which the other half of Lee's Army, Longstreet's command, might join Jackson.

Photographers and many others utilized the Warrenton Turnpike as well. In March 1862, George Barnard and James Gibson recorded no fewer than eleven images at locations along the pike. In 1865, Alexander Gardner's crew, as well as a huge party of dignitaries and soldiers, traveled on the Warrenton Turnpike to the dedication of the 1865 memorials erected at Groveton. Since the road served as the main artery for the two series of wartime images of the Manassas Battlefields, sites along its route are particularly well documented.

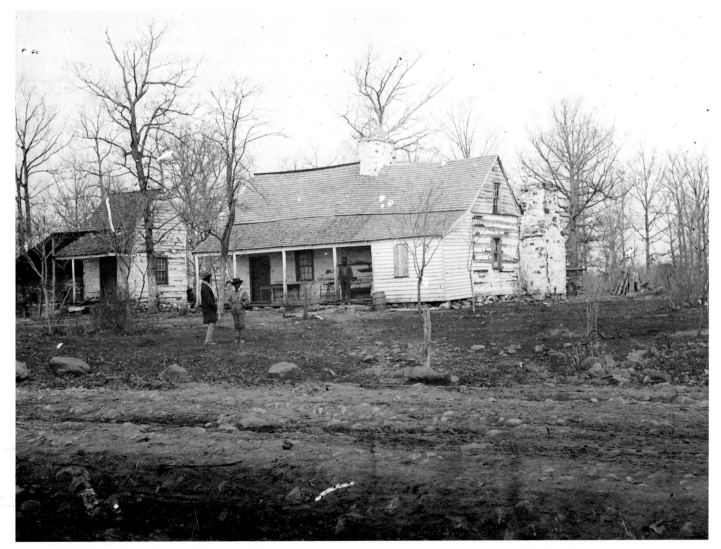

Mrs. Spindle's House, Barnard, March 1862, LC. General McDowell's 1861 plan to flank the Confederates out of their Bull Run position depended on most of the advancing force turning right, off the Turnpike, before reaching the home of a Mrs. Spindle. The Union routes of retreat converged near the Spindle home and the roads were clogged. Confederates in close pursuit pushed artillery up the hill near it to bombard their retreating foe. George Barnard recorded two images of this house which had been used as a field hospital after the battle. The rocky Warrenton Turnpike is visible in the foreground.

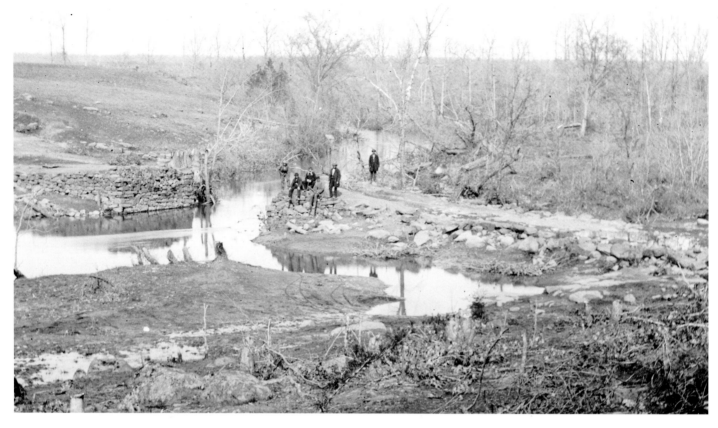

The Remains of the Cub Run Bridge, Barnard, March 1862, LC. This humble-looking crossing of Cub Run on the Warrenton Turnpike was the scene of the most chaotic part of the retreat for the Union army. The first shot of Kemper's Confederate battery exploded directly above the bridge and overturned a wagon that blocked the Union artery of retreat. A withdrawal now became a rout. With no effective way to cross the stream, Union gunners abandoned their guns, soldiers and civilians threw down their possessions and splashed into the water. The Cub Run bridge was replaced several times thereafter and is now a substantial four-lane, elevated bridge, surrounded by townhouses.

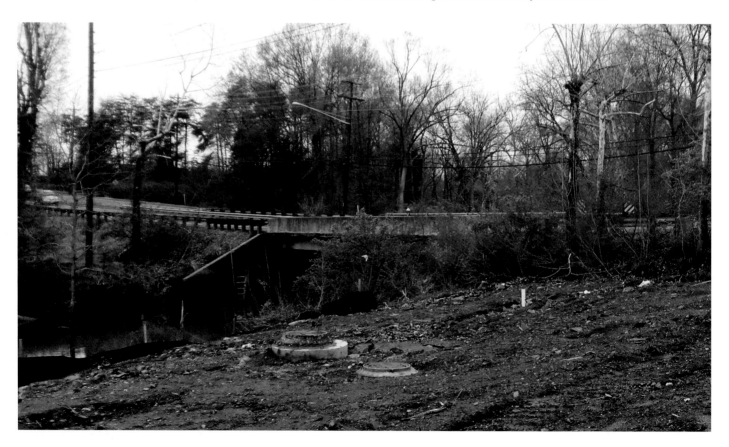

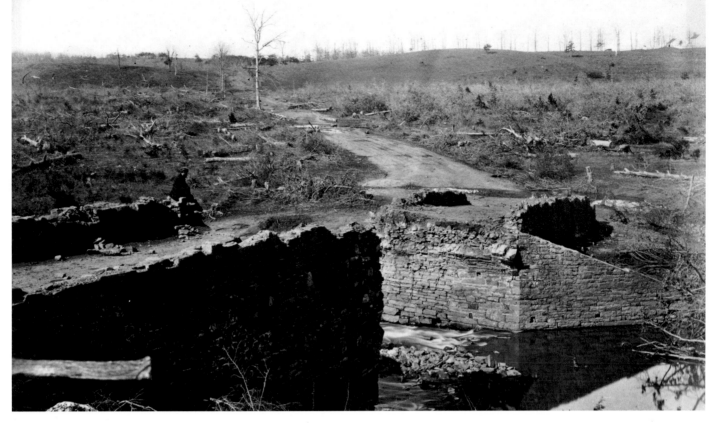

Ruins of the Stone Bridge, Barnard, March 1862, LC. One of the most iconic symbols of the Manassas Battlefield, the Stone Bridge predated the Civil War by more than 35 years. Between the battles, just after Confederates destroyed the bridge with gunpowder in March 1862, Barnard and Gibson recorded at least six views of the wrecked bridge from various angles. While the bridge was soon made serviceable with a temporary wooden span, it was not fully rebuilt until the 1880s and remained open to traffic until 1926, when the road was rerouted and a new bridge, visible at left in the modern photo, was constructed alongside.

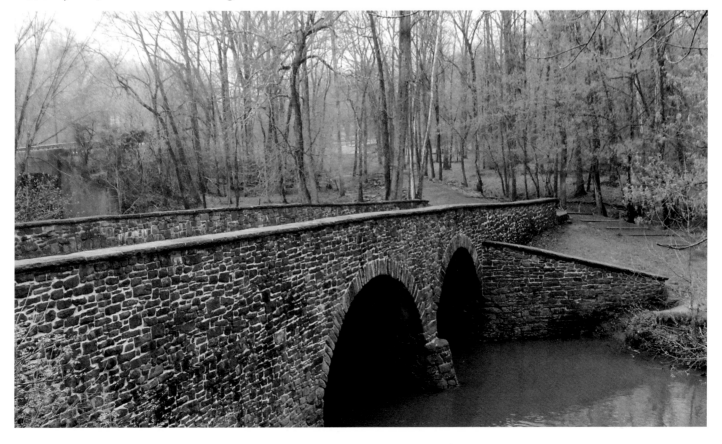

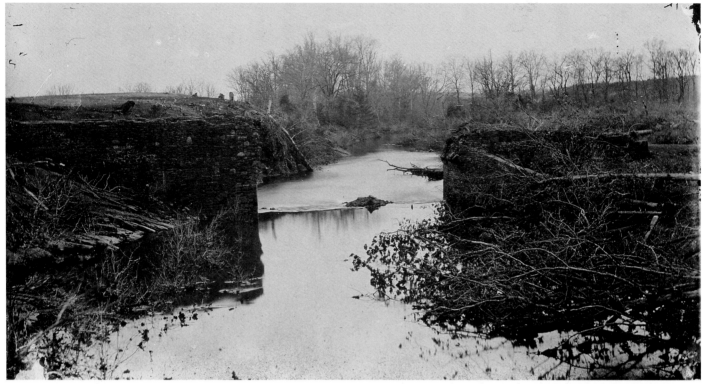

Ruins of the Stone Bridge, Looking Upstream and Downstream, Barnard, March 1862, *(ABOVE)* NARA, *(BELOW)* LC.
Captain E.P. Alexander recalled the particulars of the bridge's demise and provided a framework for future visitors to picture the event:

I was directed to blow up the old Stone Bridge—an arch of about 20 feet—when all had crossed, & Maj. Duffey and I mined the abutments & loaded them, & then the major remained & fired the mines at the proper time. I have always wanted to revisit the spot, which was quite a pretty one in those days, but I never had the chance, though I went across Sudley Ford, only two or three miles off, in Sept. '62. I will probably never see it again, but if any of my kids, or kid's-kids, ever travel that Warrenton Pike across Bull Run they may imagine Maj. Duffey & myself, on a raft underneath the bridge mining holes in the abutments, & loading them with 500 lbs. of gunpowder & fixing fuses on hanging planks to blow up both sides simultaneously.

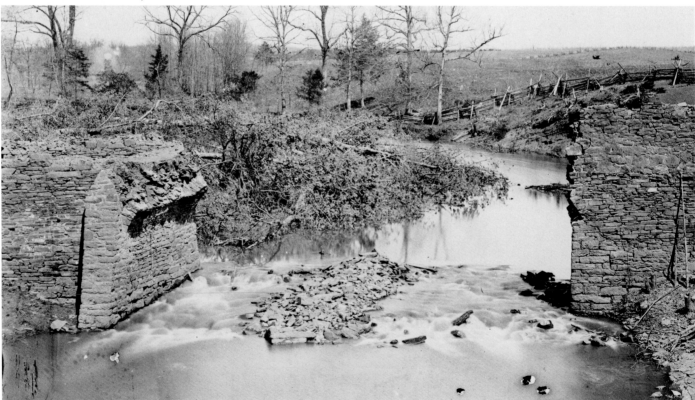

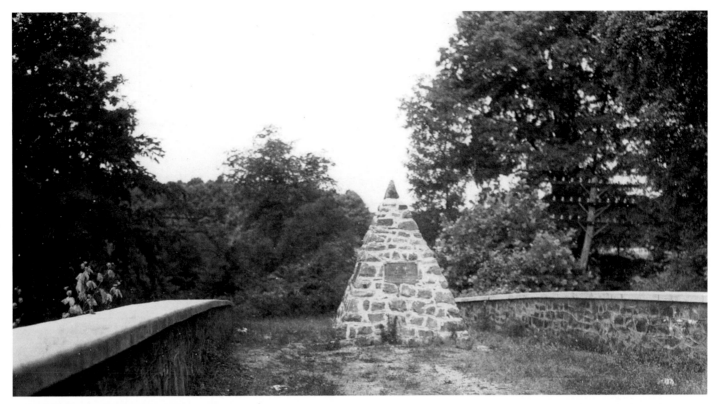

The Stone Bridge with Pyramid Monument, c. 1940, MNB. In 1928, two years after the Stone Bridge was closed to traffic, the Virginia State Highway Commission presented this pyramidal monument to the Manassas chapter of the United Daughters of the Confederacy. The monument remained in the center of the bridge until just before the 100th anniversary of the First Battle of Manassas, when the bridge was restored to its original condition.

Stone Bridge Cannon, c. 1960, MNB. The National Park Service took ownership of the historic bridge in 1959. When the pyramidal monument was removed it was at least temporarily replaced by a 30-pounder Parrott Rifle like that which opened the First Battle of Manassas from the heights east of the bridge.

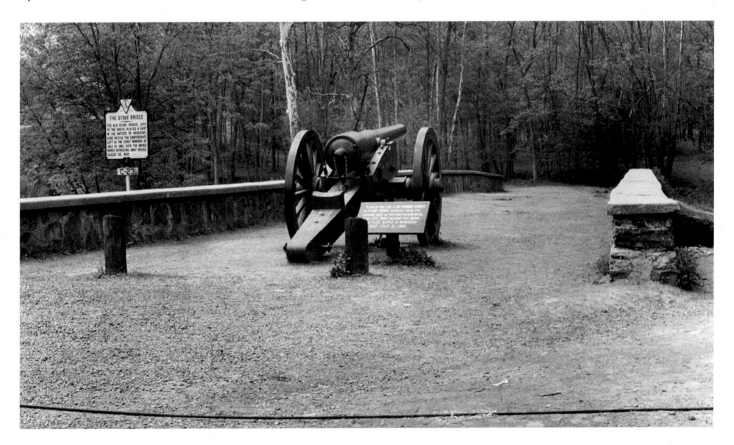

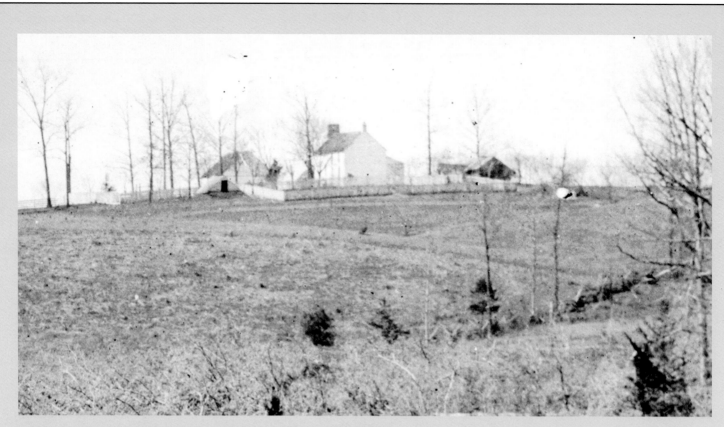

Detail of Image Showing the Van Pelt House, Barnard, March 1862, LC. Situated above and west of the Stone Bridge, Abraham Van Pelt's house was captured on at least three of photographer George Barnard's glass plates. The Van Pelt house is strongly associated with key events at the beginning of the First Battle of Manassas. Confederate infantry at First Manassas took position on the hill overlooking the bridge to guard against Union troops who might try to cross Bull Run. Captain E. P. Alexander placed a signal station just outside the house and, eight miles away on Wilcoxen's (or Signal) Hill, spied the grand Union flanking movement beyond the Van Pelt house. Union artillerist Lieutenant Peter Hains, who was chosen to open the battle with his 30-pound rifled cannon, scored a direct hit on the Van Pelt house. Hains recalled that the house "stood out large and white, a target for my gun which I could hardly miss." A following shot struck the signal tent outside the house. The Van Pelt house did, however, survive both battles, only to be destroyed by fire in 1932. House ruins were visible for decades, as shown below, but today only ground depressions remain.

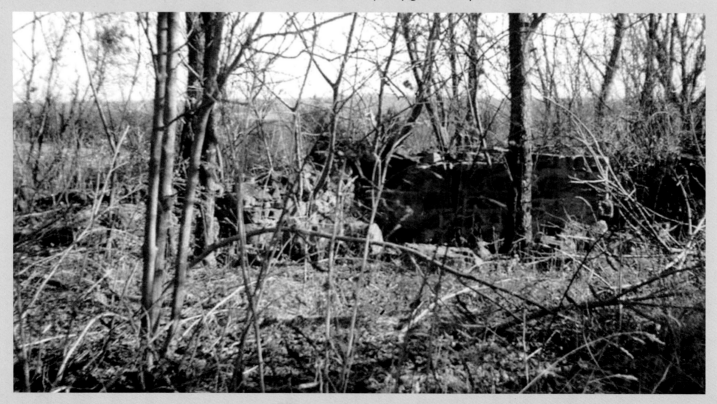

NORTH OF THE TURNPIKE

George Barnard's photographic team recorded at least eight images in the community known as Sudley Springs. The village of Sudley could boast of having a mill, a church, two fords, scattered houses, and even one home identified as a "mansion." Given Sudley's importance to First Manassas, where the main Union flanking force, consisting of Hunter's and Heintzelman's Divisions, crossed Catharpin Run, to attack the Confederates from the north, Barnard spent ample time covering the area. I have included four of the seven images here.

Barnard also recorded one known image at Matthew's Hill and two more of the Stone House on the Warrenton Turnpike, While historians might wish that photographers recorded just a few more images at a few more places, the three areas Barnard photographed north of the Turnpike represent the key points in the opening phases of the battle—McDowell's flank march and crossing of Catharpin Run, the initial actions on Matthews Hill and the movements and inaction around the Stone House.

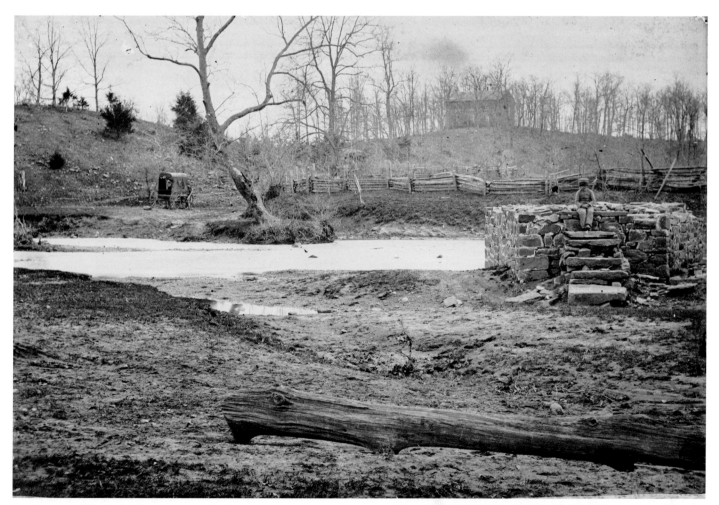

Looking Across Catharpin Run at Sudley Springs Ford Toward Sudley Church, Barnard, March 1862, LC. In their flanking march to the battlefield, Union troops actually crossed two streams at two fords near Sudley—Bull Run/Sudley Ford and Catharpin Run/Sudley Springs Ford. Barnard focused his lenses solely on the latter. Here, the spring in the right foreground serves as a seat for a young boy wearing Confederate gray. Catharpin (pronounced CAT-HARR-PIN) Run and Sudley Church, amidst the trees in the distance, complete Barnard's composition. The wagon sitting in the left distance may be the mobile darkroom in which most of the historic images in this book were developed.

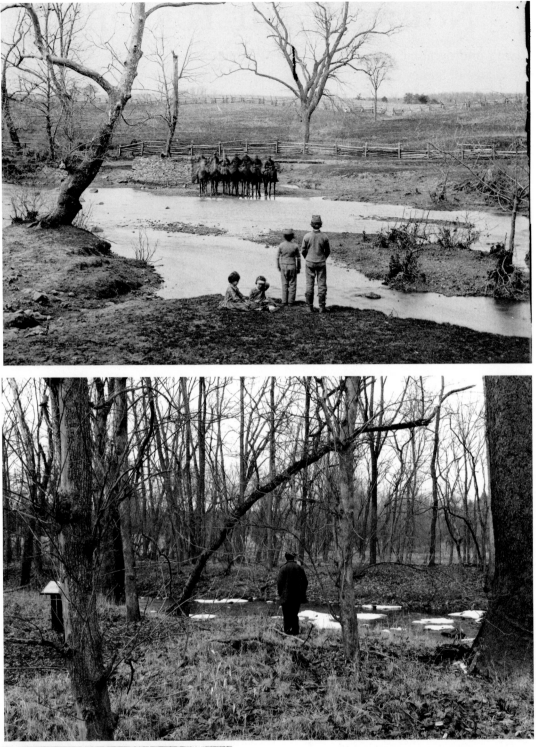

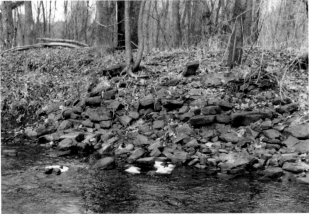

Sudley Springs Ford Over Catharpin Run, Barnard, March 1862, LC. In this striking image, Barnard managed to capture four children seemingly facing off against seven Union cavalrymen on the opposite bank. One or more of the kids appear in all four of the Sudley-area images presented here. While the area is largely overgrown, a small trail leads to the ford. On the opposite bank you can still see the remains of the spring's rock structure *(LEFT)*. National Park Service Museum Specialist Jim Burgess stands approximately where the children stood in 1862.

Soldier Graves Below Sudley Church, Barnard, March 1862, LC. July 21, 1861, was a Sunday. Local residents dressed in their finest to attend services at Sudley Church. Soon the area was inundated with thousands of soldiers and by early afternoon the house of worship was filled with Union dead and wounded. Dead soldiers were buried all around the church in temporary graves, including those shown here, marked with simple stakes and arrayed around the Confederate-attired boys. Barnard recorded two almost identical scenes here. The church has been rebuilt and enlarged over the years but occupies the same ground as it did during the Civil War. The road in the foreground of the modern image is Featherbed Lane.

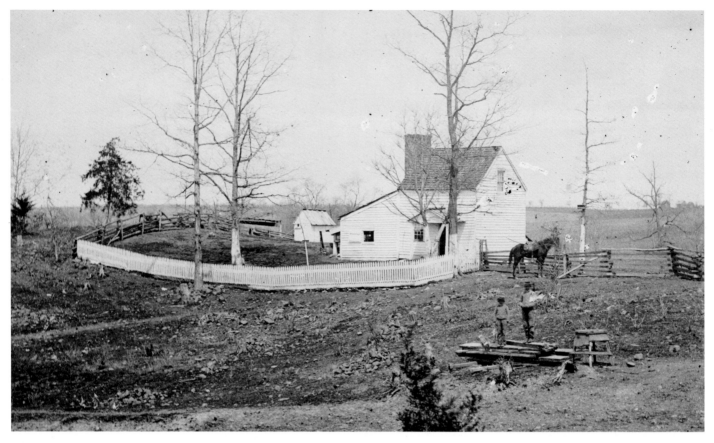

The Thornberry House, Barnard, March 1862, LC. Identified in its original caption as "Thorburn's House, Bull Run" and later by the Library of Congress as William Thornton's house, this image actually shows John Thornberry's house at Sudley. An inquisitive neighbor alerted National Park Service staff that the image's traditional location might be in error. Indeed it was. The terrain and structure line up perfectly, even when seen through the modern foliage. Historian Jim Burgess has all but proven that the children visible in Barnard's Sudley series are those of John Thornberry.

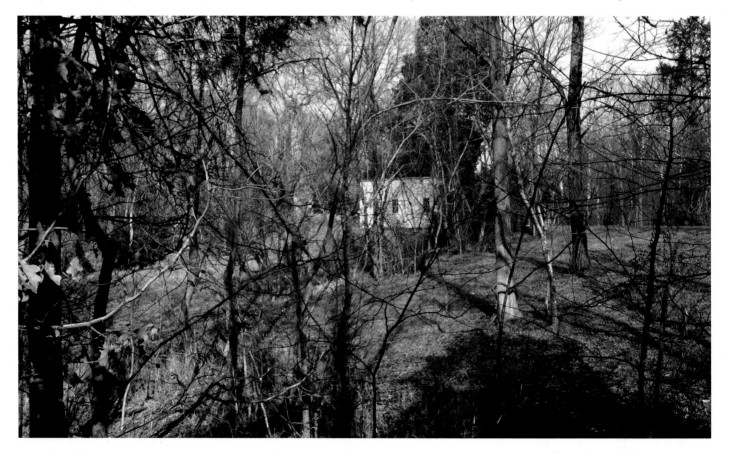

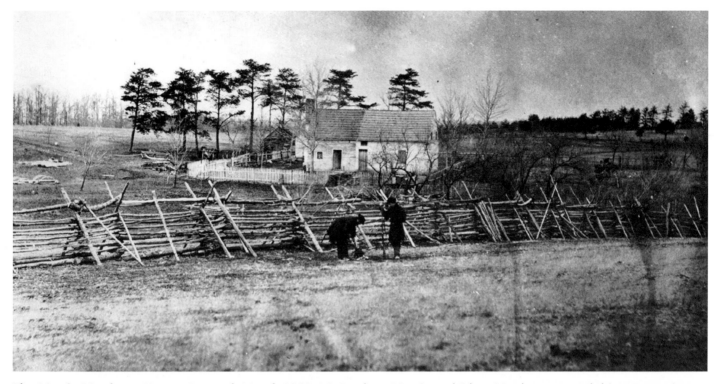

The Martin Matthews House, Barnard, March 1862, LC. Brothers Martin and Edgar Matthews owned this unassuming dwelling near the Sudley Road between the Warrenton Turnpike and Sudley. General McDowell's flanking maneuver and Confederate Colonel Nathan "Shanks" Evans' response placed the house directly in the whirlwind of the opening of the greatest battle, up to that time, in American history. Dense woods currently occupy much of the open ground in the 1862 image, including the site of the Matthews house. The fence in the modern image was placed by the National Park Service to recreate the historic fence line in the photograph.

It is odd that this is the only known plate that Barnard exposed in this area. Given the work involved in grazing horses, preparing chemicals and pouring the tacky collodion mixture onto glass plates, it is highly unusual for a Civil War photographer in the field to record only one image at a particular location. It is possible that Barnard at least attempted to record additional views, however, and that these either turned out to be poor exposures or, hopefully, are additional 1862 images at Manassas that have yet to resurface.

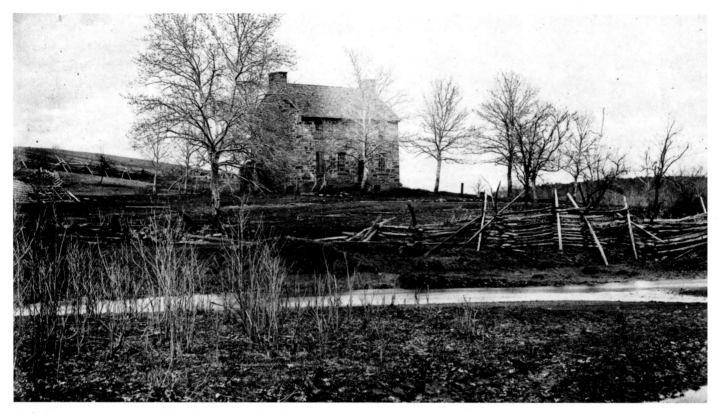

The Stone House, Barnard & Gibson, March 1862, LC. Along with the Stone Bridge over Bull Run and the stone remnants of the Henry House chimney, the Stone House is on a short list of Manassas Battlefield icons and is the only one that remains in its original state. This image is one of only three Manassas Battlefield images that appear in (Alexander) Gardner's *Photographic Sketchbook of the Civil War*. It shows the Stone House rising above Young's Branch with Buck Hill visible in the left background. Although long under NPS stewardship, the intersection of Sudley Road and the Warrenton Turnpike has become highly congested since the Civil War and remains an area begging for restoration to a simpler time. The house is often open to visitors and contains soldier graffiti. Changes to the original camera position's terrain, probably the result of the modernization of Sudley Road at Young's Branch, required my taking the modern photo closer to Young's Branch, eliminating the stream proper from the image.

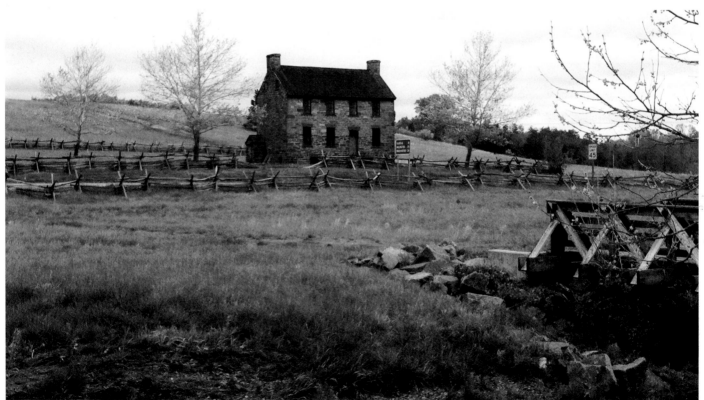

HENRY HILL

Henry Hill is the only part of the Manassas National Battlefield that was photographed by both Barnard in 1862 and Gardner in 1865. This is not surprising. Henry Hill hosted more sustained action, soaked up more blood and became more famous than any other First Manassas location. Numerous photo opportunities, including battlefield graves, house ruins, early monuments and the landscape of the war's first battlefield, led to greater wartime photographic coverage on Henry Hill than anywhere else in the area. Roaming the fields of Henry Hill, Barnard recorded no fewer than eight photographs in 1862, while Gardner's team captured at least ten more in 1865. Complementing the photographic coverage were the drawings and engravings of battlefield artists, some of which were created after the fighting in 1861 while Confederates occupied the area. These images show the Henry House before the battle-damaged structure was dismantled for firewood, lumber and souvenirs.

With its proximity to Washington, D.C., and the notoriety of the war's first, great battle, veterans flocked to the field, and on Henry Hill they found one of Judith Henry's sons, who would not only listen to their stories but labored to mark the locations of significant events. Henry Hill was destined to become synonymous not only with the First Battle of Manassas, but with the fields that comprise both battles.

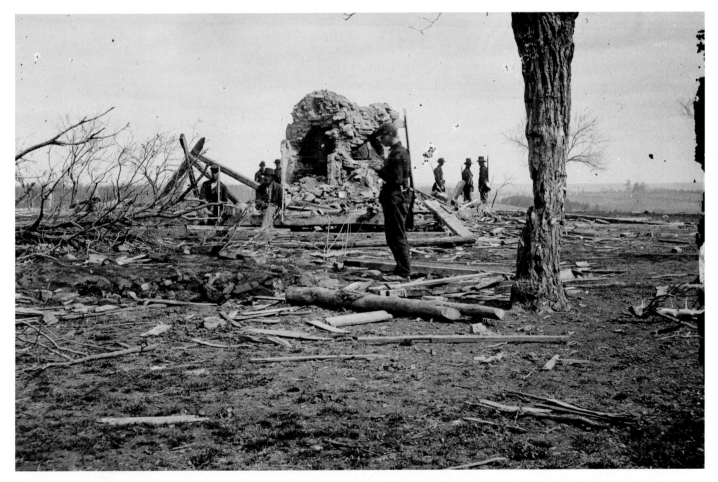

Ruins of Judith Henry's House, Barnard, March 1862, LC. Judith Henry paid the ultimate price at the First Battle of Manassas. Killed during the shelling that damaged her home, Henry was the first civilian fatality in the war's first battle. Barnard's team recorded two close-up views of what was left of the house, which sustained heavy damage during the battle but was reduced to a pile of rubble during the eight months the Confederates camped in the area after the battle. This view looks approximately northward.

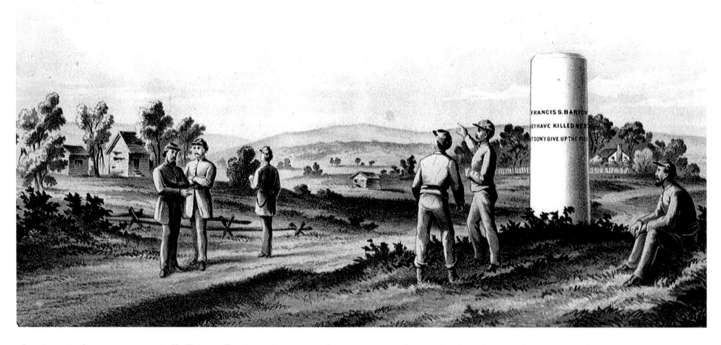

The Spot Where Bartow Fell, "WPM", 1861, MNB. Within two months of the battle, Confederate soldiers erected a memorial to mark the place where Colonel Francis H. Bartow of Georgia fell. Although the artist's intention was to show the memorial, the complete absence of photographs of the Manassas Battlefield before March 1862 makes this and any 1861 illustration worthy of study. In fact except for this engraving and two other period drawings, no primary graphics exist showing the Henry House or the Bartow monument as they stood. The Bartow memorial disappeared around the time of the Union occupation of the area. Only a small stone remains at the base of the tree at right in the modern photo. The newer Bartow monument is visible in front of this tree.

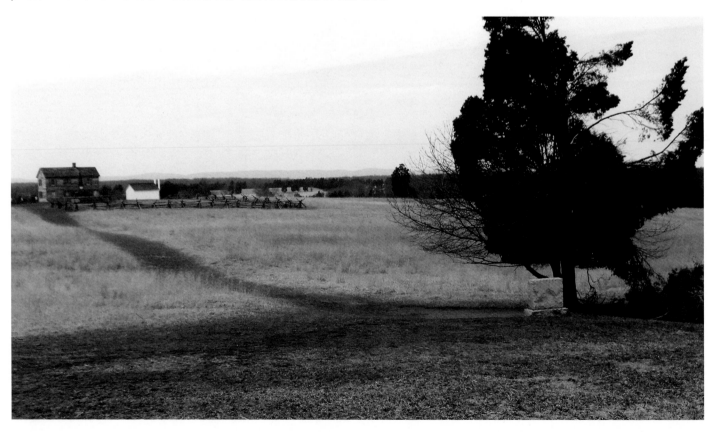

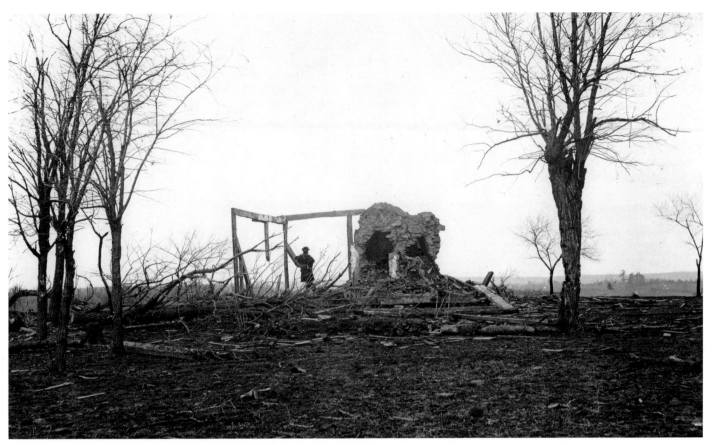

Ruins of Judith Henry's House, Barnard & Gibson, March 1862, LC. Similar to the stereo image of the Henry ruins, this plate version, exposed before the last part of the frame structure came down, provides a more expansive view of the house site. The Carter house, known as "Pittsylvania," is barely visible in the right distance. The span of Judith Henry's life can be traced within the confines of this image—she was born at Pittsylvania, died near the chimney ruins and was buried just beyond the small trees at left. Her grave is visible at left in the modern photo.

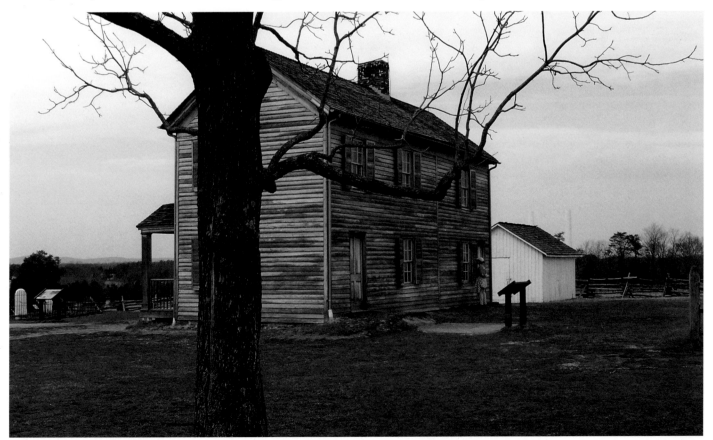

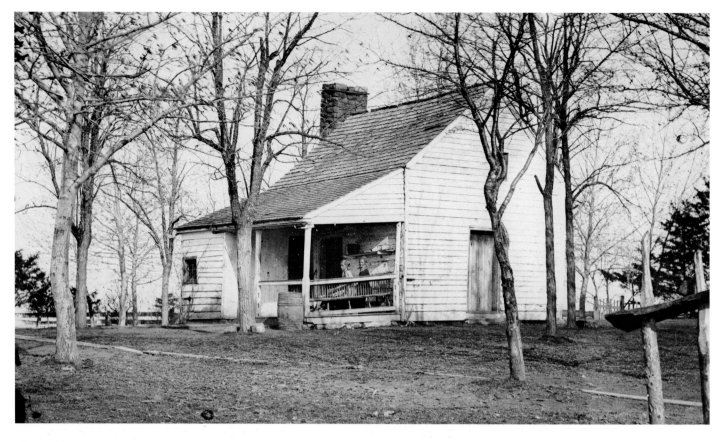

The Robinson House, Barnard, March 1862, LC. George Barnard recorded at least three images in the immediate vicinity of the home of James Robinson, a free black man whose dwelling sat on a rise above the Warrenton Turnpike. In this image, two women, most likely family members, sit on the porch. Beyond the house can be seen the fence bordering the Robinson lane—a Confederate position during the first battle. The remaining foundation visible in the modern photograph encompasses some of the original structure as well as the larger structure pictured on the following page. This image looks generally northeastward.

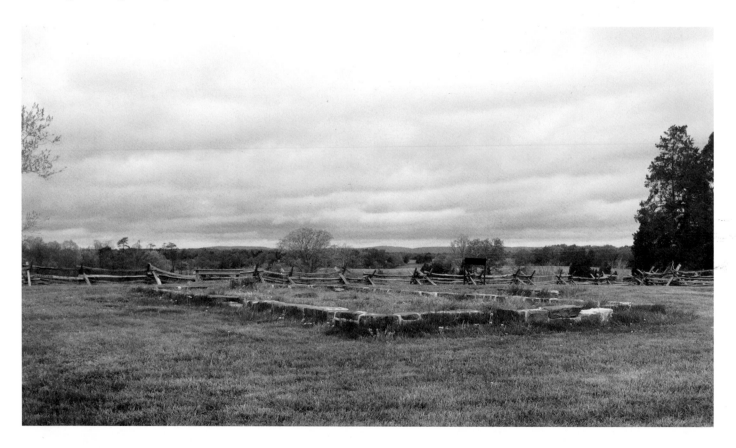

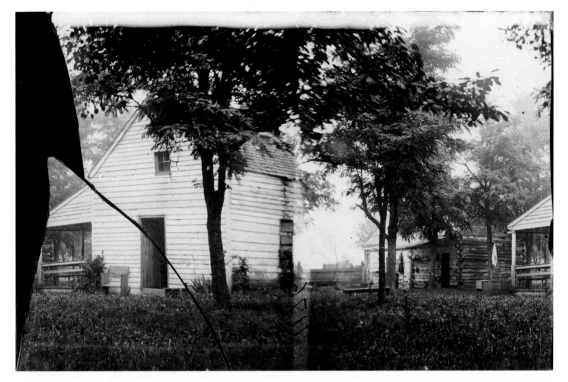

The Robinson House, probably Alexander Gardner, June 1865, LC. This partially damaged and incomplete stereoview was recorded from an angle roughly 90 degrees counterclockwise from Barnard's views of the house and looks toward the scene of the heaviest fighting at First Manassas. Foliage precludes it being part of Barnard's 1862 series and is therefore most likely part of Gardner's June 1865 series. Gardner recorded at least ten other views on Henry Hill, so it makes sense that this is his work. All of Gardner's other images are plate views, however. It makes little sense that the team brought along a separate stereo camera only to use it once (and for an ultimately inferior photo). Perhaps all the other stereo-sized glass plates were broken, or perhaps other images await discovery. We are left wondering how many other photos could have been, or were, recorded that day.

The Robinson House, c. late 1920s, MNB. In 1926, the Robinson house was enlarged to include a broader footprint and a second story. The Civil War-era house is visible at left in the trees at a similar angle to that recorded by Barnard. The extant foundation mostly represents the footprint of the enlarged structure that stood for 67 years before it was consumed by fire.

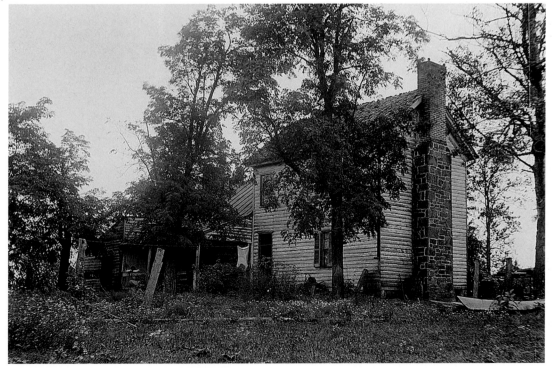

Henry Hill Looking Southeast, Barnard & Gibson, stereo, 1862, LC, composite work by John Kelley. As detailed by Jim Burgess in 2004, Barnard recorded this image from just southeast of the Robinson House (probably from atop Mr. Robinson's barn). No other wartime photograph shows such an expanse of the bloodiest parts of the battlefield. Most of the action on Henry Hill took place within the bounds of this photograph—a composite of both sides of the stereoview.

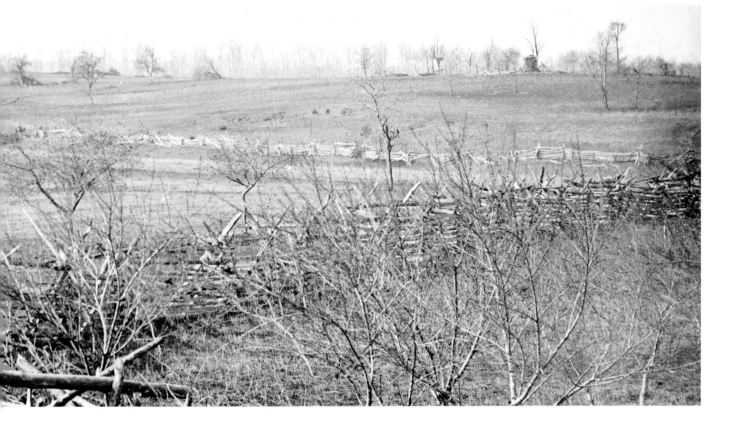

In the right distance, the ruins of the Henry House are visible. On the left and right of the Henry House sat the batteries of James Ricketts and Charles Griffin, around which the battle flowed. The tree line in the left distance marks the position of Jackson's troops, penetrated by Union troops during the fighting. Somewhere in the center distance of this photograph, General Barnard Bee first uttered Jackson's lasting sobriquet—"Stonewall." Today, a line of trees blocks the original camera position, so I created the modern, digital file at ground level just to the southwest of where Barnard's crew exposed his plates to the sun 149 years earlier.

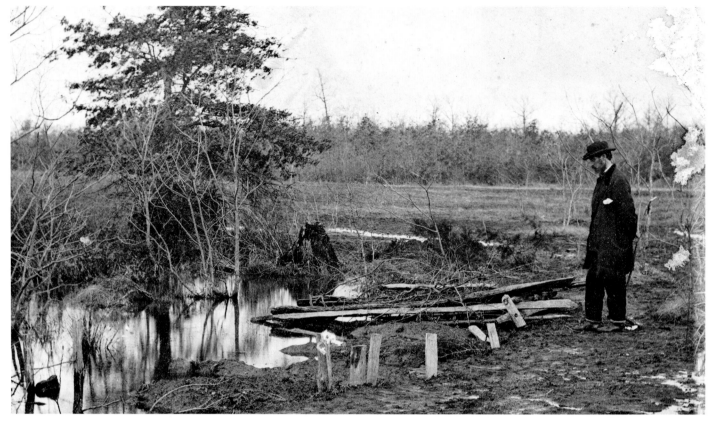

Soldier Graves on Henry Hill, Barnard, March 1862, LC. George Barnard's team recorded three images of graves in a marshy, wet patch of ground on the Bull Run Battlefield. No additional information was provided in the original caption. Using a map drawn by a Wisconsin soldier and undertaking a battlefield investigation, Manassas National Battlefield's Jim Burgess and historian Keith Knoke determined that the location of the watery graves was on Henry Hill, just a few yards east of the current NPS visitor center parking lot. As is visible in the modern photo, the location still becomes soggy with rainwater to this day. See the sidebar in this section for more information on this series and what can be learned from visually scouring the original glass negatives for information.

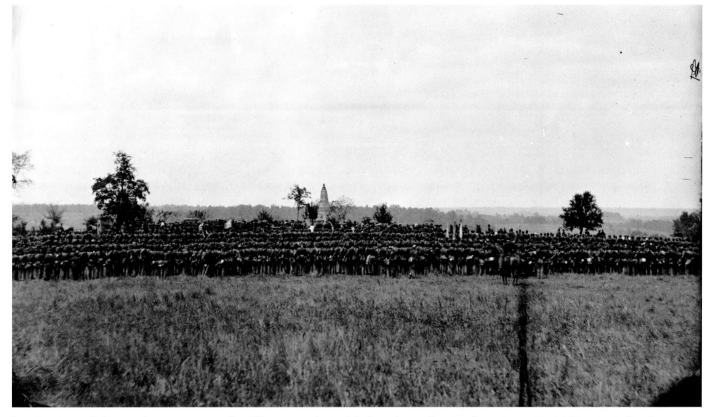

"Dedication of the Battle Monument," William Morris Smith for Alexander Gardner, June 11, 1865, LC. Following the May 1865 Grand Review in Washington, with patriotic sentiment running high, the Army approved plans for two memorials "in honor of the Patriots" who fell on the battlefields at Manassas. Both memorials were completed on June 10, 1865, and were consecrated the following afternoon. Alexander Gardner, his brother James, and assistant William Morris Smith were the only known photographic team to record the ceremonies. The brand-new memorial on Henry Hill is seen here, with members of the 8th Illinois Cavalry, the 5th Pennsylvania Heavy Artillery and 16th Massachusetts Light Artillery standing in formation, facing northward.

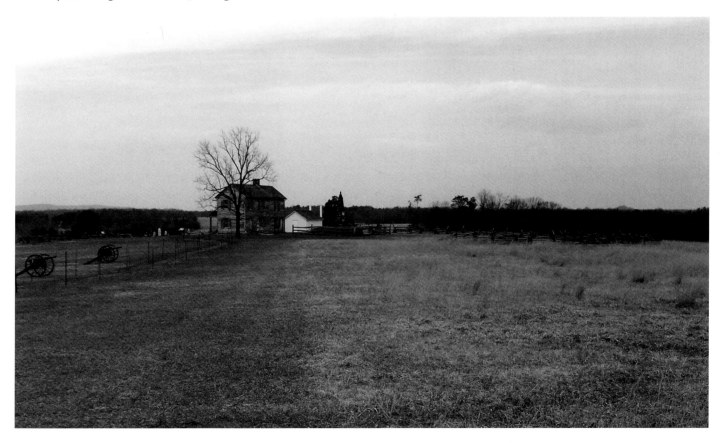

STUDY THE DETAILS

In a March/April 2004 *Military Images* article entitled "Bull Run Discovered," Keith Knoke and Jim Burgess unveiled their discovery of the two locations where four of Barnard's photographs were recorded on Henry Hill. Mining the details in the background of the images, using an obscure reference on a Wisconsin soldier's hand-drawn map and conducting a field investigation, the pair convincingly argued that both images were indeed recorded on Henry Hill, and provide previously unknown glimpses of the historic spot. But there is more to the story. Using their research and the new, ultra-high resolution scans of the original glass plate negatives at the Library of Congress, unavailable seven years earlier, I was able to confirm their sites beyond the shadow of a doubt. I located the same trees in the background of all four images and confirmed that all were taken in the same, general direction.

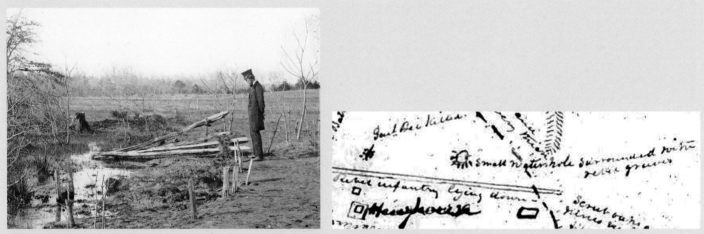

Confederate Graves on Henry Hill, Barnard, March 1862, LC *(LEFT)* and Charles K. Dean Map, April 1862, MNB *(RIGHT)*. By comparing these three images of Confederate graves around a small wet area with the compelling reference on Lt. Charles Dean's 1862 hand-drawn map, Knoke and Burgess established the location of the images. Dean's sketch includes a small circle with hash marks identified as "small waterhole surrounded by rebel graves." Dean also notes the location of the Henry House and the spot where General Bee was killed.

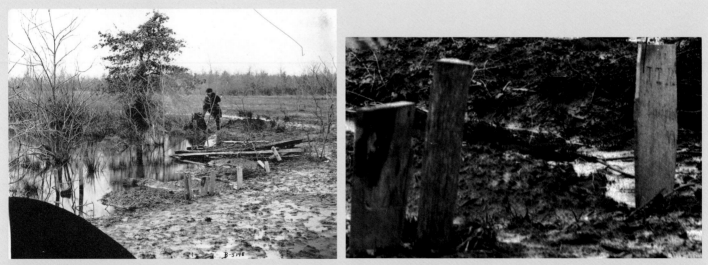

Confederate Graves on Henry Hill, Barnard, March 1862, NARA and detail. This view, which looks in a more southerly direction than other photos recorded here, exposes the faces of some of the temporary headboards. In viewing a high quality scan secured at the National Archives, the grave at right in the detail view appears to read "JTM Lexington." If this interpretation is correct, it's likely that the body of 27-year-old former teacher James T. McCorkle of the Rockbridge Grays, Co. H, 4th Virginia Infantry, killed nearby on July 21, 1861, rests under that headboard.

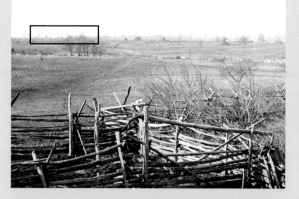

Henry Hill from the Robinson Farm with detail, Barnard, March 1862, LC and *(BELOW)* Confederate Graves on Henry Hill with detail, Barnard, March 1862, LC. In the backgrounds of these images, I discovered that the trees in each were not only the same but are also oriented in the same general direction. The small tree that sits on the edge of the waterhole is most likely visible as a dark smudge in the lower extreme left of the distant view above.

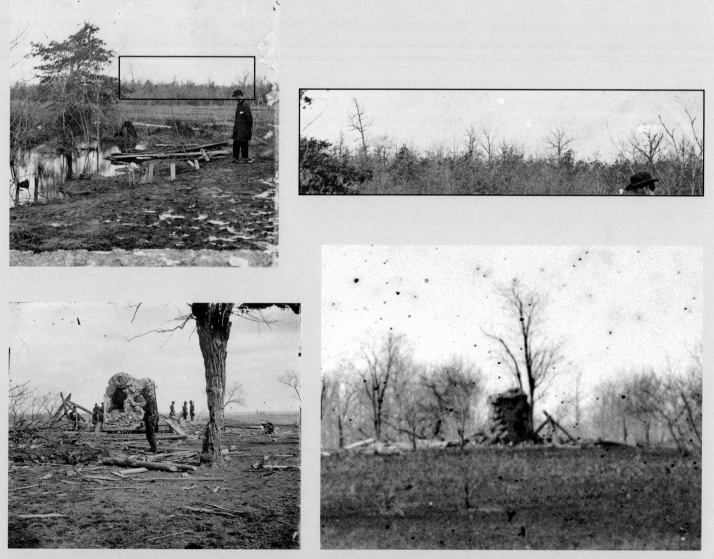

Ruins of the Henry House, Barnard, March 1862, LC and *(RIGHT)* detail of Henry Hill from the Robinson Farm, Barnard, March 1862, LC. The Henry ruins image's northeastward orientation is easily established by the presence of the "Pittsylvania" house, visible on the right horizon. Knowing this, and by using the chimney ruins and the remaining, house frame skeleton, it is simple to establish the view at right as taken from the direction of the Robinson Farm.

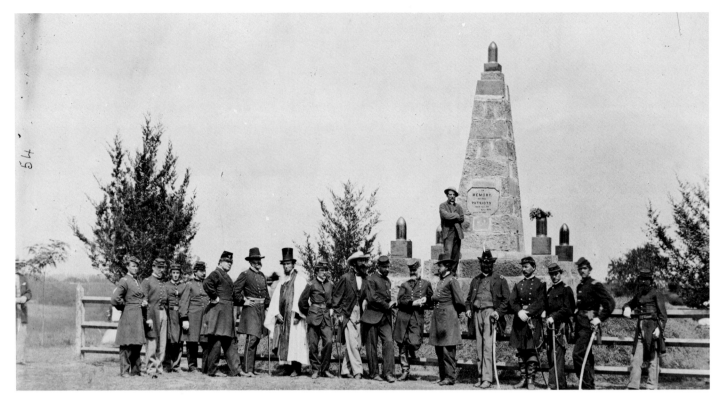

Dignitaries at the Consecration of the Bull Run Monument, William Morris Smith for Alexander Gardner, June 11, 1865, LC. Numerous dignitaries were on hand for the special event, including the eight generals, three captains, five lieutenants, and the colonel, minister, doctor and judge in this photo. The monument's architect, Lt. James McCallum, stands, appropriately, upon his creation.

The Men Who Built the Memorial, William Morris Smith for Alexander Gardner, June 11, 1865, LC. Posing around the twenty-foot tall memorials and amidst the *live* 200-pound Parrott shells are some of the men of the 5th Pennsylvania Heavy Artillery who built the two nearly identical monuments on Henry Hill and at the Deep Cut. The stone was scavenged from the unfinished railroad and hauled by these men and erected under the supervision of architect McCallum, a stonemason by profession, who stands cross-armed in both views on the memorial.

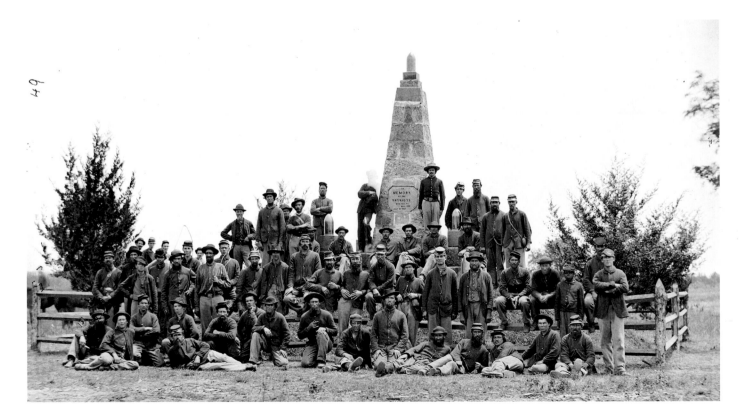

WEST OF SUDLEY ROAD

While some of the fighting in the two battles at Manassas was fought on the same ground, the two clashes mostly occurred on opposite sides of Sudley Road—the 1861 battle to the east, the larger, second conflict in 1862 to the west. Yet, on Chinn Ridge, Henry Hill, in Sudley Road, and on Dogan's Ridge, soldiers could truly say they fought on the same ground twice. Despite Second Manassas's place as one of the bloodiest battles of the Civil War (with more than four times the casualties of the first battle), the Second Manassas battlefield has long been relegated to a place of lesser importance in public memory. Soldiers wrote fewer words about it, visitors saw it less, and early photographers all but shunned it. Many features abound on the sprawling fields of strife west of Sudley, but not a single photograph was taken in the area during the war and only one known photograph was taken just after. Even as photographers finally ventured out to the Second Manassas battlefield in the 1880s and 1890s their coverage could hardly be called comprehensive. Most of the few 19th century photos of Second Manassas show the Deep Cut, the area around the crossroads at Groveton, or some of the ground in between. Only decades later did photographers open their shutters at places such as the Brawner Farm and Stuart's Hill.

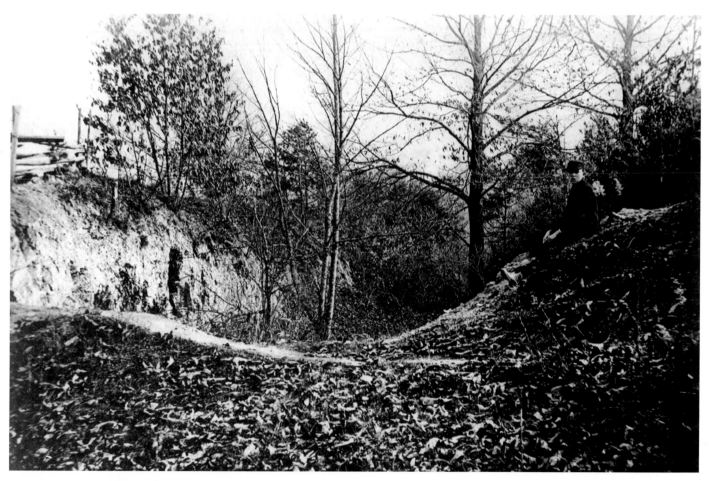

The Deep Cut, c. 1880s, MNB. On August 28, 1862, Stonewall Jackson positioned his troops along the unfinished Independent Line of the Manassas Gap Railroad. Again and again, Union General Pope's forces assaulted Jackson at the railroad bed. These generally uncoordinated attacks penetrated Jackson's line, but the Confederates pushed each of them back with heavy casualties. The Southerners held firm but were strained to the breaking point—some defenders were reduced to throwing rocks for want of ammunition. The railroad line was never completed and the scene of these fierce struggles is now part of the Manassas National Battlefield.

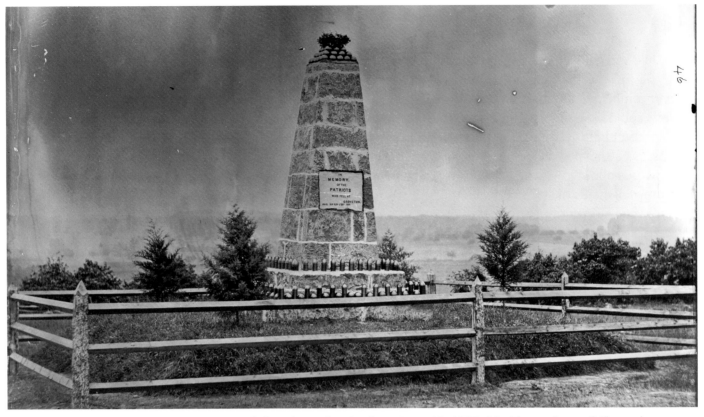

Groveton Monument, William Morris Smith for Alexander Gardner, June 11, 1865, LC. The register of Alexander Gardner's negatives lists three photographs taken of the Groveton monument, but I have thus far been able to confirm only one. Pictures of the Henry Hill monument are often listed as the Groveton monument but the telltale stacked cannonballs atop the monument (versus an artillery shell atop the Henry Hill monument) illustrate which is which. Artillery projectiles, still lying plentifully near the Deep Cut in 1865, were placed on the memorial for its dedication—on the same day as the ceremony on Henry Hill. This is the only known 1860s photograph taken on the Second Manassas battlefield. Beyond the monument we see the generally open ground between the unfinished railroad and the Warrenton Turnpike.

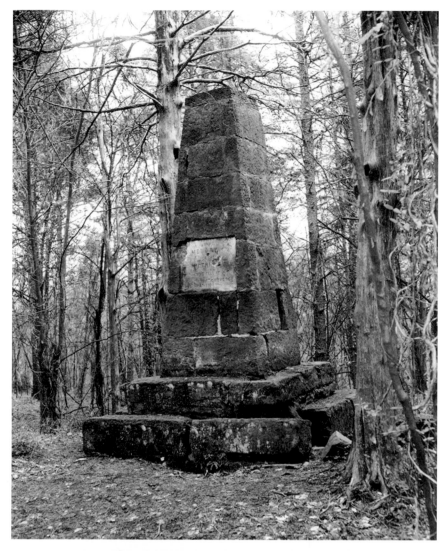

(LEFT) The Groveton Monument, H.E. Churchill, 1940, MNB. The Manassas battlefield memorials were built quickly and could not stand the test of time without preservation and maintenance. This was especially true for the isolated and rarely visited Groveton monument. As the small cedar trees planted around the memorial upon its completion, as well as scores of other trees, grew to maturity, the monument's mortar crumbled, its weight shifted, and its red sandstone blocks deteriorated.

(BELOW) The Groveton Monument, detail, c. 1940s, MNB. Time was not the only enemy. Weakened and defaced by vandals who carved their own initials on a monument honoring long-gone patriots, the memorial was in danger of destruction. Fortunately, the National Park Service has restored the monuments.

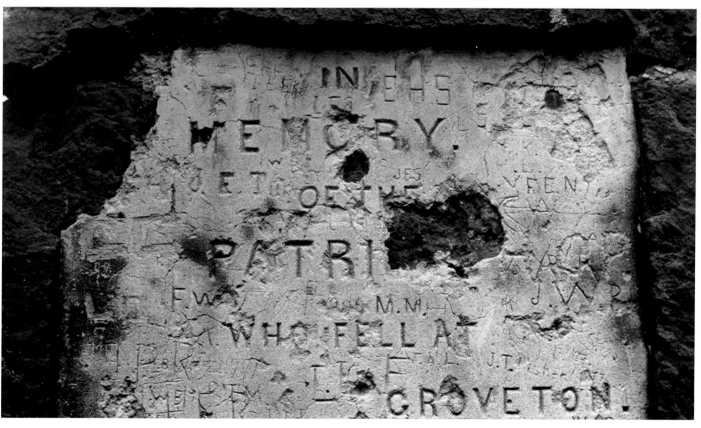

Groveton, Looking North from the Warrenton Turnpike, Albert Kern, 1908, from the collections of Dayton History. The hamlet of Groveton sat at the intersection of the Warrenton Turnpike and the Groveton-Sudley Road. From the open fields in the left distance, Union forces attacking strongly positioned Confederates in the distant wood line. The Lucinda Dogan House, visible at left at the northwest corner of the intersection, came under the protection of the National Park Service in 1949. Due to changes at this intersection, I recorded the modern photo from a slightly different location.

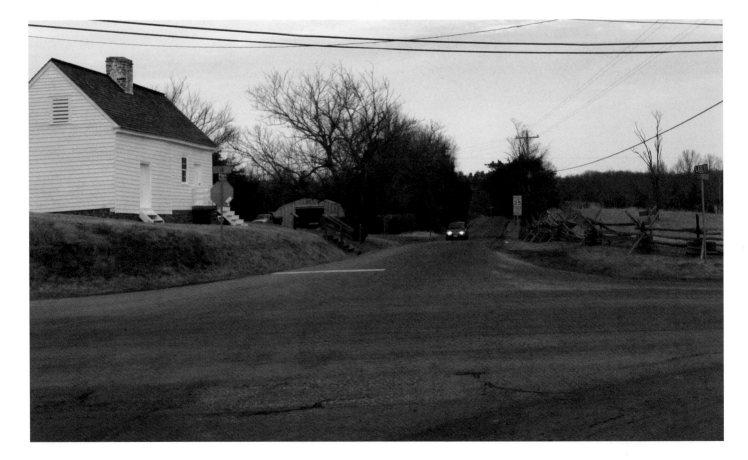

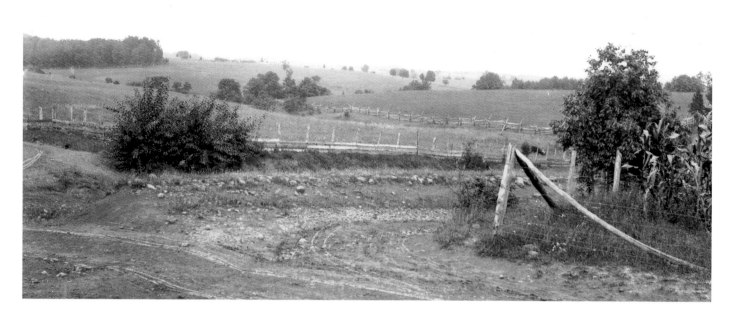

"Second Manassas. View of Groveton, Looking Northeast," Albert Kern, 1908, from the collections of Dayton History. This view, which almost forms a panorama with the previous historic image, looks northeastward toward the distant fields that hosted particularly bloody encounters, like much of the land north of the Turnpike. In the last phase of the battle, James Longstreet's Confederates unleashed a powerful attack along and south of the road, just off of the right border of this image.

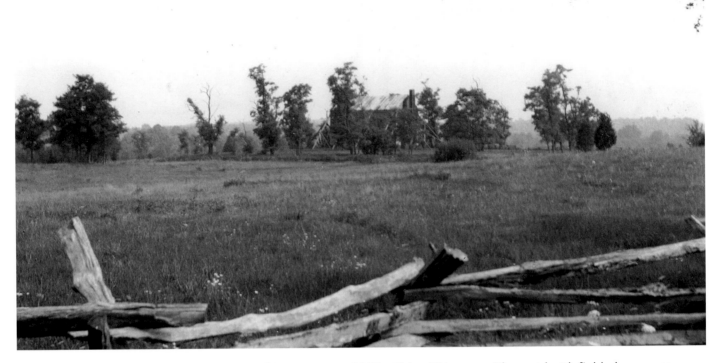

Looking South on Chinn Ridge toward the Chinn House, c. 1940s. Chinn Ridge, as with most battlefield places, was not a commonly used name until after the battle. Even then, it was generally known as Bald Hill. When the term Chinn Ridge ultimately became more popular, Bald Hill was a name relegated to another, nearby prominence. Regardless of nomenclature, fighting swirled on this ground in both battles. During First Bull Run in 1861, Colonel Jubal Early's brigade lined up in front of the Chinn house. The following year, the advancing Confederate line passed on both sides of the house as it moved toward the camera position.

Close-up view of the Chinn House Exterior, c. 1940s. The Chinn House, also called Hazel Plain and used as a hospital in both battles, slowly succumbed to the ravages of time after the war. It was stabilized in the 1930s, but ultimately collapsed. Only the foundation remains today. The modern photo proves that the stone foundation is the same one that saw Hazel Plain through both battles. Though almost none of the house still exists, it still provides a direct connection to the past, using photographs taken more than seven decades after the Civil War.

A Monument Moved, Changed and Rarely Seen

Many monuments on Civil War battlefields purport to mark the location where particular events occurred. The Lee-Longstreet monument, which aims to mark the spot where Generals Lee, Longstreet and Jackson met just after noon on August 29, 1862, during Second Bull Run, is no exception. Many of these location-specific monuments, however, have been relocated without the necessary changes being made to the text. When monuments have been moved, including some at Gettysburg, Chickamauga, Antietam, Shiloh, and this at Manassas, it may be just as important to know where *they were*, as where they are today.

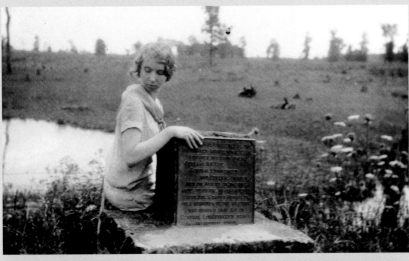

The Lee-Longstreet Monument, L. Carper, c. 1940s, MNB. The Lee-Longstreet Monument was originally placed in a field south of the Warrenton Turnpike, west of Pageland Lane, but was later moved to sit directly on the south side of the turnpike, as pictured here. In the winter months, the pond in the left of the picture is still visible through the trees along the busy pike today. The identity of the young woman sitting on the monument is unknown.

Workman Reinstalling the Enlarged Lee-Longstreet Monument, 1987, MNB. In the 1980s, the monument was moved again, most likely due to roadwork. It was placed on the median strip between the four lanes of Route 29, but after it was struck and damaged by a car in the mid-1980s, it was moved and built up with stones at its present location—west of Pageland Lane on the north side of Route 29, where thousands of cars speed by, not even noticing.

MYSTERIES AND CURIOSITIES

The effective use of Civil War photographs as primary, historical documents requires often frustrating, but ultimately rewarding, hours of careful study. As William A. Frassanito demonstrated more than 35 years ago, determining when, where and by whom an image was recorded can transform a photograph into an almost unparalleled historic resource, rich in information. Despite the growing body of work devoted to Civil War photography, lifetimes of research remain to be done and Manassas is no exception. Mysteries and curiosities abound, from unknown locations to unattributed photographers to incorrect captions. It is my hope that presenting some of these images will lead to further scrutiny, which may reveal additional bits of information that will ultimately lead to the discovery of unknown photo locations.

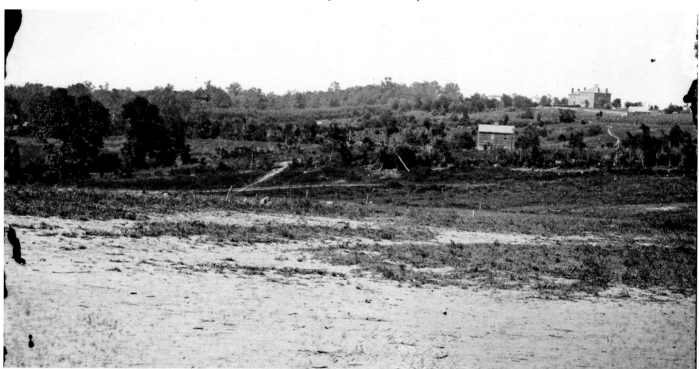

"Bull Run, Virginia, the Battlefield" c. 1860s, photographer unknown, LC. Although captioned as such, this photo is almost certainly not recorded on or even near the Manassas National Battlefield. The detail below shows a large house on the horizon and it is inconceivable that such a substantial structure could have been on the battlefield but is completely unknown to the National Park Service and to historians today. Its location, even its approximate location, is unknown. Perhaps a reader of this book will recognize this house in another photograph or while driving the Virginia countryside and will solve this enduring mystery.

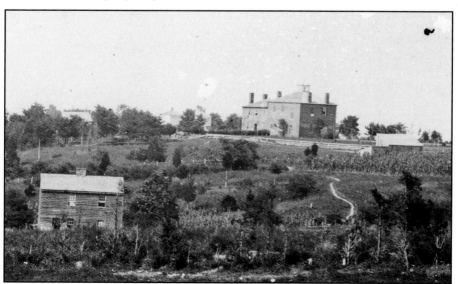

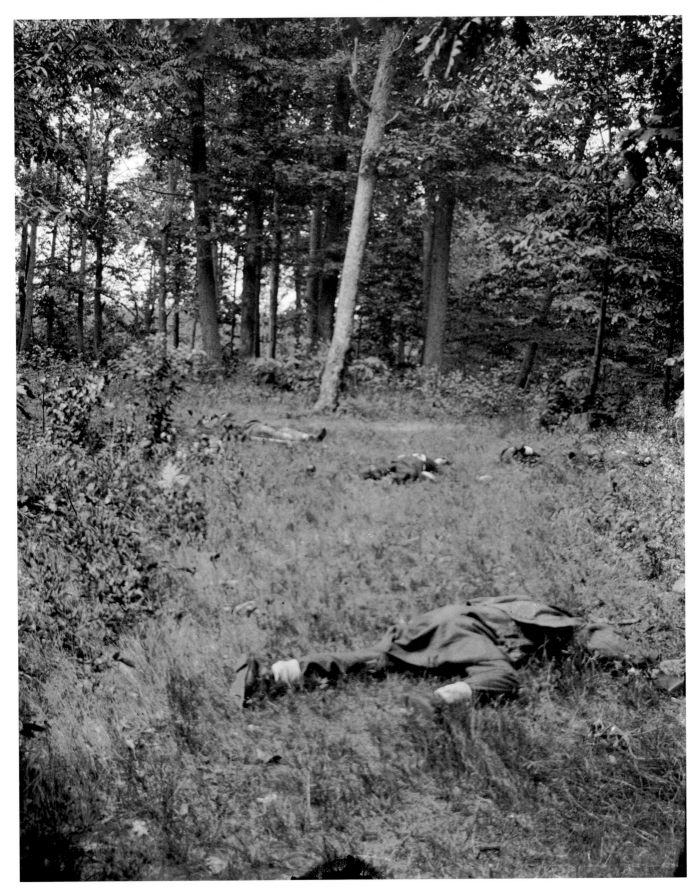

"Confederate Dead on Matthews Hill," probably by a Brady assistant, c. 1861, LC. This image was for many years assumed to show exactly what was captioned, but photo historian William A. Frassanito considered it odd that at least two of the dead soldiers in the image were wearing overcoats at the scene of a summer battle. That's not the only thing that struck Frassanito about this photograph; the scene also seemed familiar to him.

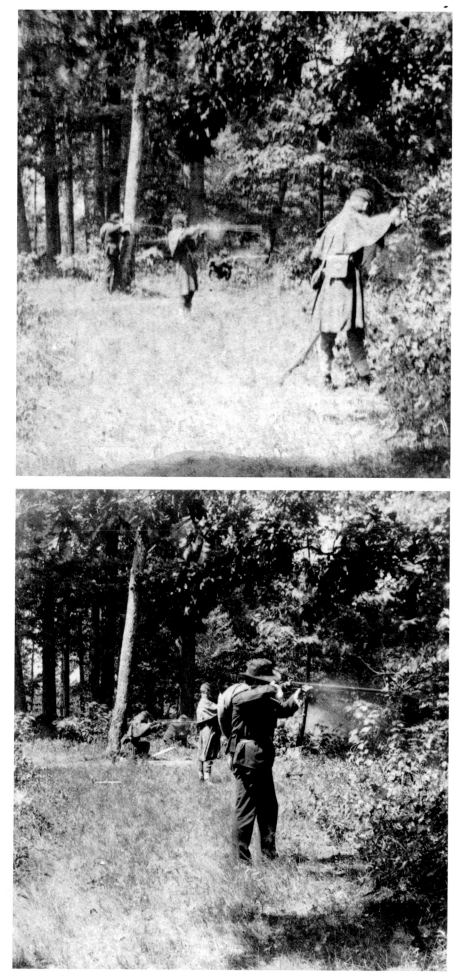

Union Soldiers Firing Guns, probably a Brady assistant, c. 1861, Robin Stanford Collection. Producing a Xerox copy of a picture he had seen at the Library of Congress years earlier, Frassanito quickly recognized the significance of this image: it showed the same soldiers, "very much alive," in the exact same place! He presented this discovery in his 1978 book *Antietam: The Photographic Legacy of America's Bloodiest Day.*

Union Soldiers in the Woods, probably a Brady assistant, c. 1861, Robin Stanford Collection. The implications are clear: either an intrepid photographer secured two images of these four soldiers in two different positions and then these same men suffered a 100% death rate at that spot or, of course, the photographer asked the soldiers to lie down and pose as dead for the camera. Perhaps the photographer or his boss thought better of actually publishing the staged image as "Confederate Dead on Matthews Hill" was not published until a century after the war.

WHICH BRIDGE?

In August 1862, Timothy O'Sullivan and his team created a series of images in the Centreville-Manassas vicinity that includes at least two images recorded along Bull Run. The same photographic assistant appears in both views and is holding the same stick. Both photos show repaired bridges. Since photographers rarely unhitched their teams of horses and prepared their chemicals to expose only one image, it likely that these images were recorded at or near the same place.

Are these views taken at the repaired bridge over Bull Run on the Warrenton Turnpike? On the surface, it would appear so. The Stone Bridge was known to have been destroyed and rebuilt and the size of the of the bridge's span seems consistent. Still, the terrain does not at all match that at the Stone Bridge and the features are inconsistent with those evident in the 1862 photographs of the destroyed bridge. The bridge piers appear to be too far apart to span Young's Branch or Cub Run. Most importantly, O'Sullivan did not record any known images on the Manassas Battlefield—his series was limited to Manassas and Centreville. So, which bridge is it? The answer remains a mystery.

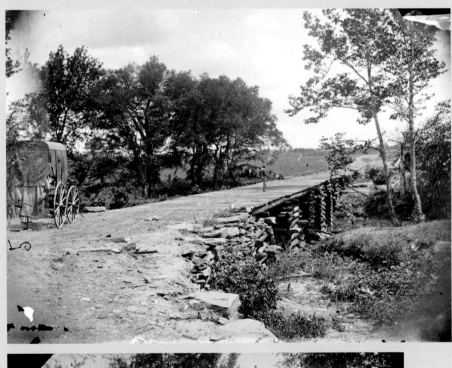

"The New Bridge at Bull Run, built by McDowell's Engineers," O'Sullivan, June 1865, LC. O'Sullivan's photographic wagon, in which this image as well as most of his August 1862 photographs was developed, is visible at left.

"View on Bull Run," O'Sullivan, June 1865, LC. This image appears to be little more than a scene of nature until viewed in detail, below, which reveals a photographic assistant standing on a fallen tree near a wrecked wagon. Behind the assistant appears a repaired bridge. Logic would suggest that this is the same bridge that appears in the view above but when viewed in 3D, the length of the logs in each view does not match. Were there two repaired bridges in close proximity? Perhaps more information will emerge if the original locations are found.

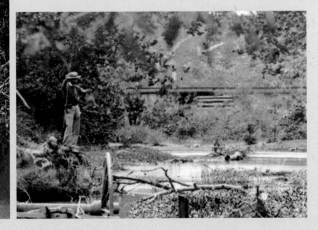

**"Near Railroad Bridge, Looking Downstream,"
Andrew Russell, May 1863, LC.** The area around Union Mills, about six miles downstream from the Stone Bridge, is a strong candidate for the location of the O'Sullivan mystery photos. There are at least two wartime photographs and a sketch that show similar log-repaired bridges, such as in this photograph, and we know that cameraman O'Sullivan was nearby when he recorded his series. *(DETAIL BELOW LEFT)*

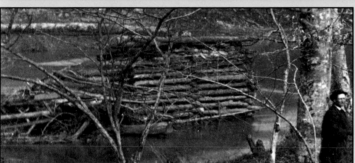

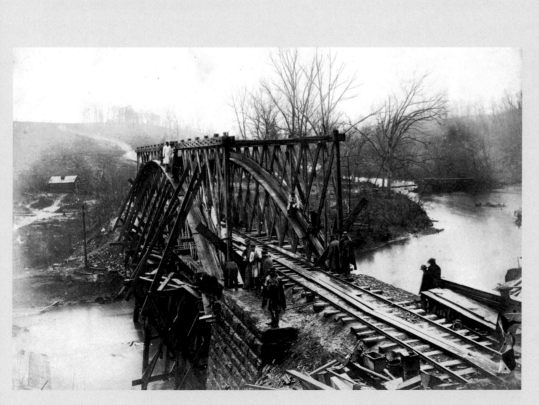

Looking upstream from the Bull Run Railroad Bridge at Union Mills, Andrew Russell, May 1863, LC. This image shows the same temporary bridge in the detail view and also seems to show a road similar to the one in O'Sullivan's June 1865 image leading uphill from the Run, but the similarities end there. The terrain does not match that in either of O'Sullivan's views and none of the trees in O'Sullivan's and Russell's views are the same. Perhaps there was another temporary bridge further downstream and some photographic evidence will finally emerge to help us find this mysterious location. *(DETAIL ABOVE RIGHT)*

"Members of the Press after the Ceremonies!!!" William Morris Smith for Alexander Gardner, June 11, 1865, Larry J. West Collection, National Portrait Gallery. This incredible view shows some of the journalists and photographers who covered the dedication ceremonies of the Bull Run and Groveton monuments,. Alexander Gardner sits at extreme left, while his brother, James, also a photographer, lounges on the ground in a black hat. New York Herald reporters S.M. Carpenter (to the right of Gardner) and L.A. Whitely (holding a dipper) are also present. The location of where the group paused to drink and smoke is unknown. Since the Groveton Monument was dedicated last and this image was recorded after the ceremonies, the most reasonable candidate would be somewhere in the vicinity of that monument. Will this prove to be a "new" image of the Second Manassas Battlefield? If so, it would double the number of known 1860s photographs on that battlefield.

"Reporters and Visitors at Dedication of Bull Run Monument," William Morris Smith for Alexander Gardner, June 11, 1865, Bob Zeller Collection. As with what is probably a companion view, above, the location of this photo is unknown. The soldiers and civilians in this photograph are unidentified and do not match with any of those in the photo above.

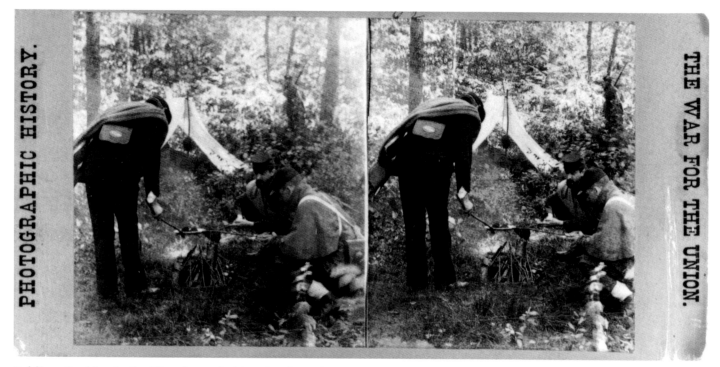

Soldiers Cooking in the Woods, probably a Brady assistant, 1861, Robin Stanford Collection. Were it not for extant versions of this photo on the original E & H.T. Anthony & Co. "War for the Union" stereo view mount, pictured here, it would be hard to believe that this is actually a Civil War photograph. The men depicted seem more to resemble 1960s reenactors than actual Civil War soldiers. Still, these are the men of 1861, about to embark upon the journey of a lifetime – an experience that so many have studied for so long. These men are long gone, but their visages can help 21st century historians unlock long-held mysteries. Is the soldier at right with his pants tucked into his socks the same man who appears in the "Confederate Dead on Matthews Hill" series? Can this photo be linked to a particular unit, and therefore to a particular camp? If so, can we discover the precise location of this and possibly other Civil War photographs?

THE CENTER FOR CIVIL WAR PHOTOGRAPHY
- HISTORY IN FOCUS -

This book was published by the Center for Civil War Photography and made possible by a generous donation from Geo Focus Engineers, Dublin, California.

The Center for Civil War Photography is a 501(c)(3) non-profit organization whose mission is to educate the public about Civil War photography, its role in the conflict, and its rich variety of forms and formats; to digitally secure original images and preserve vintage prints; to enhance the accessibility of photographs to the public; and to present interpretive programs that use stereoscopic and standard images to their fullest potential.

To join the Center for Civil War Photography, make a donation or simply learn more about the organization please visit www.civilwarphotography.org

Other books published by the Center for Civil War Photography include:

- 99 Historic Images of Civil War Charleston
- 99 Historic Images of Civil War Petersburg
- 99 Historic Images of Civil War Washington
- 99 Historic Images of Fredericksburg and Spotsylvania Civil War Sites
- 99 Historic Images of Gettysburg
- 99 Historic Images of Harpers Ferry
- 99 Historic Images of Richmond Civil War Sites
- 99 Historic Photographs of Culp's Hill, Gettysburg, PA

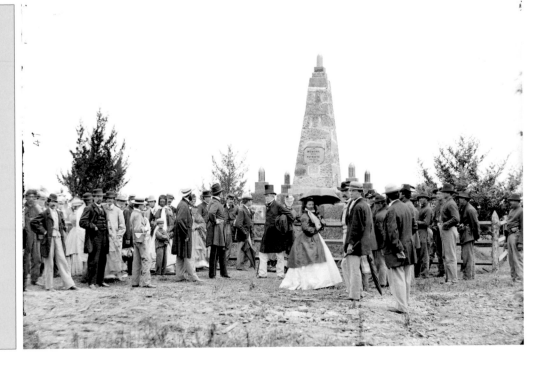